# Tattoo Designs For Beginners

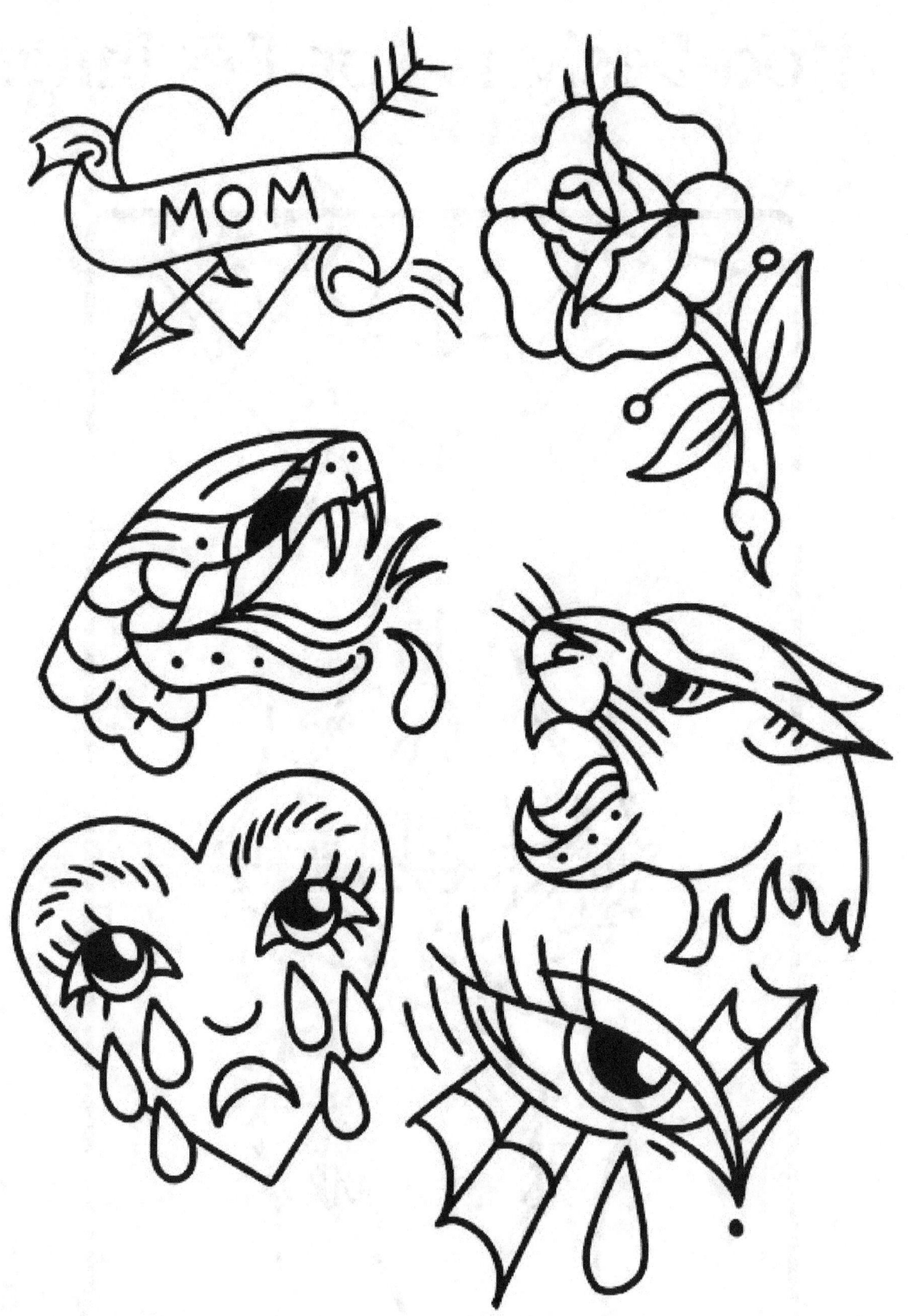

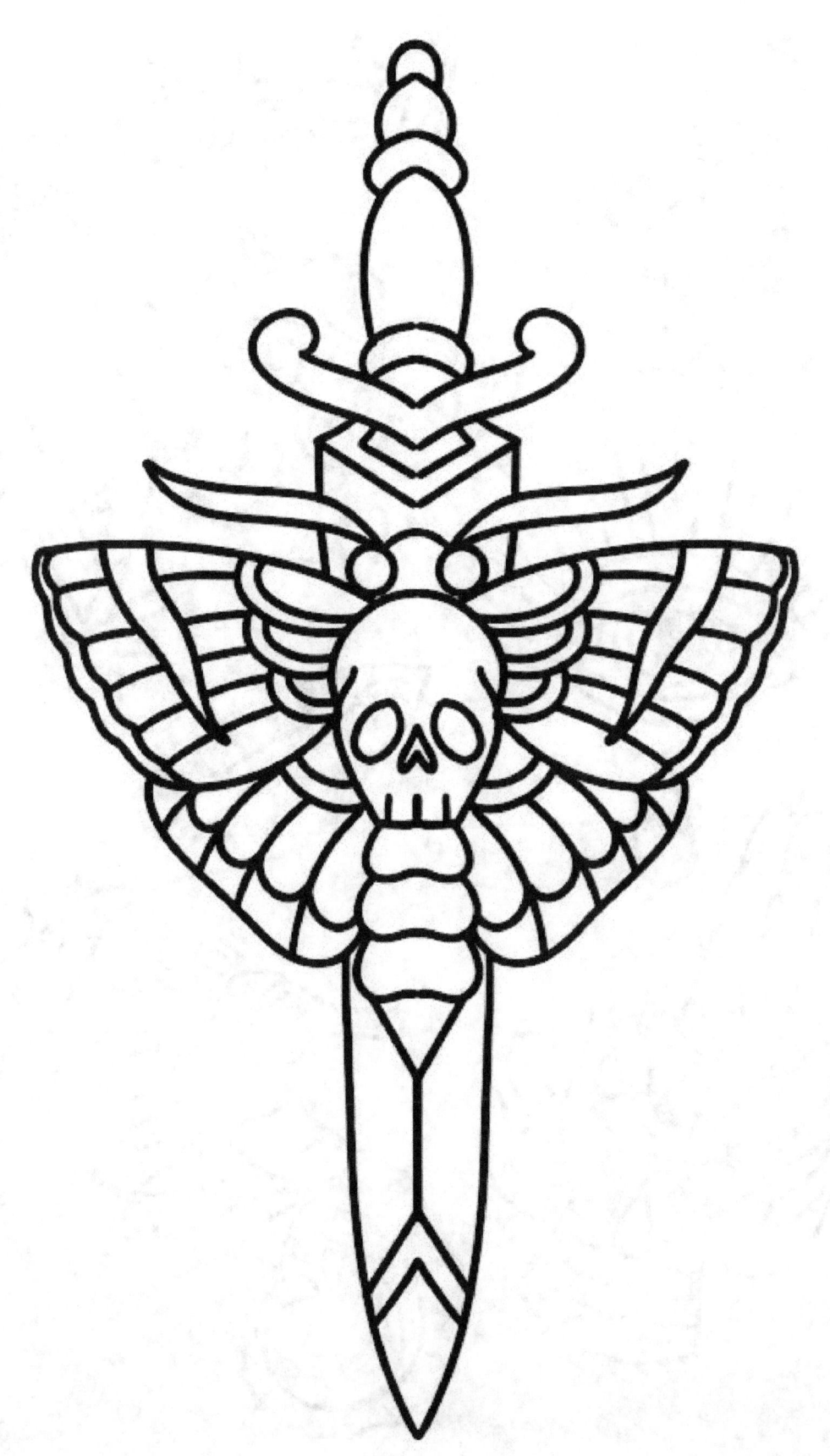

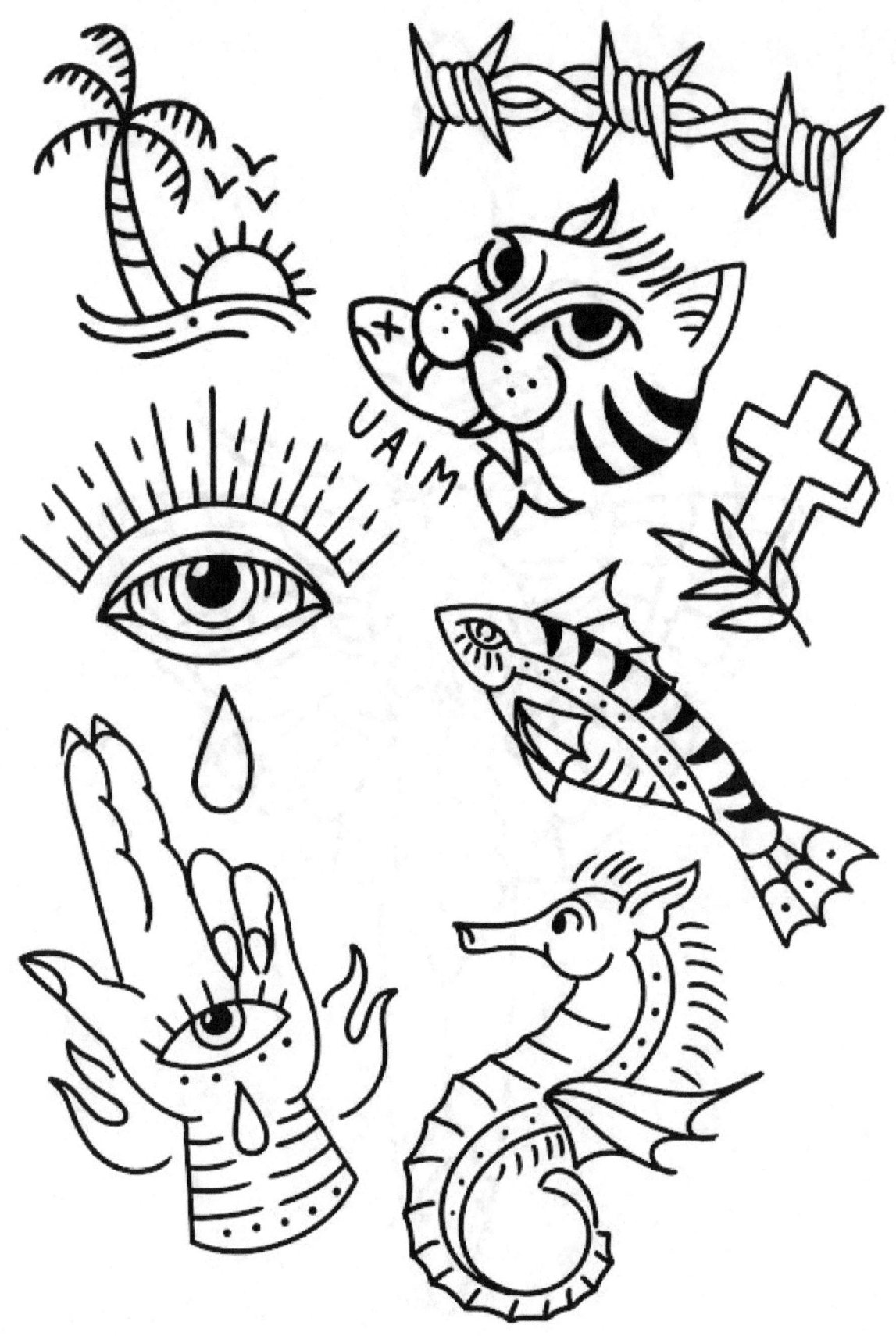

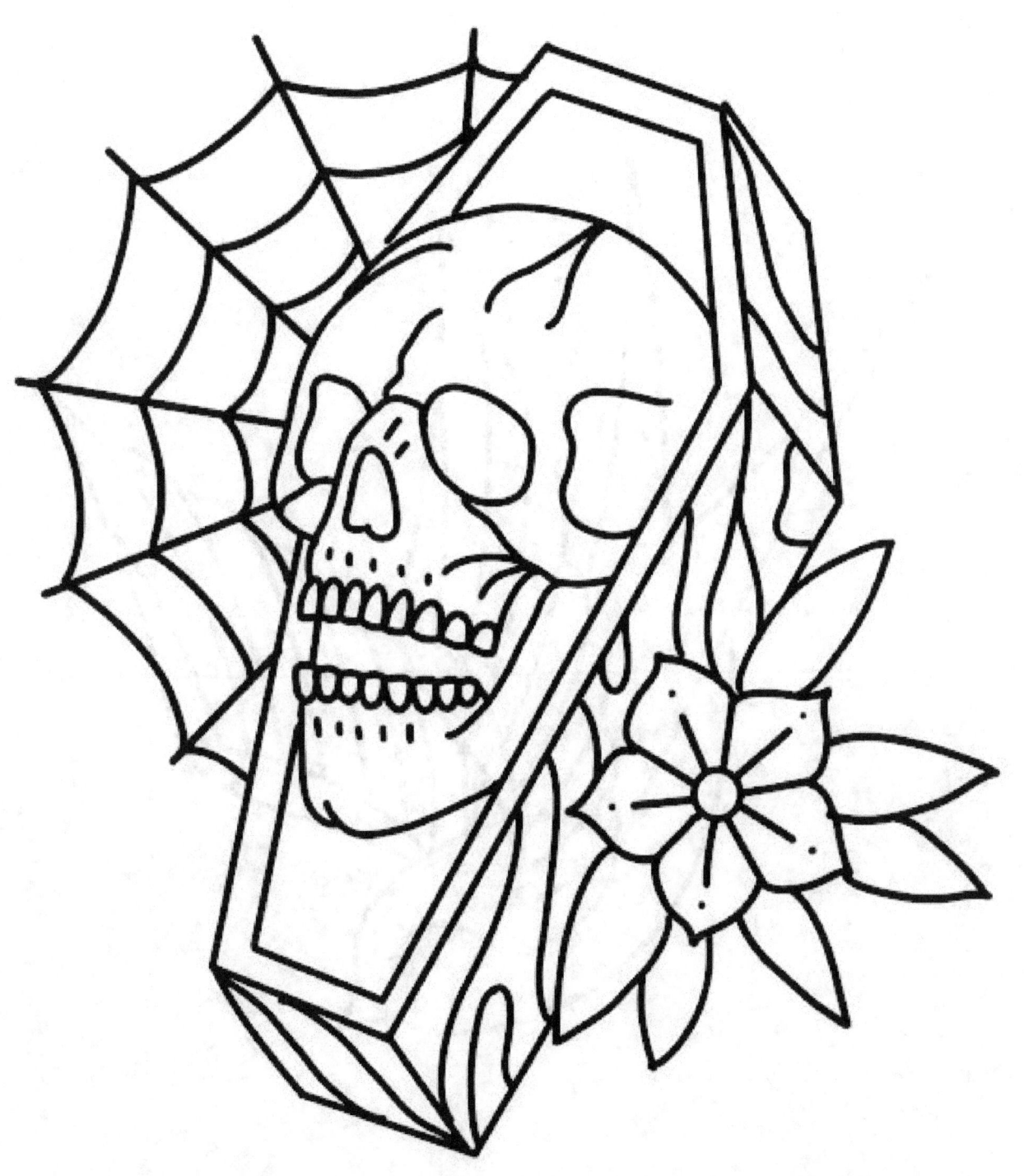

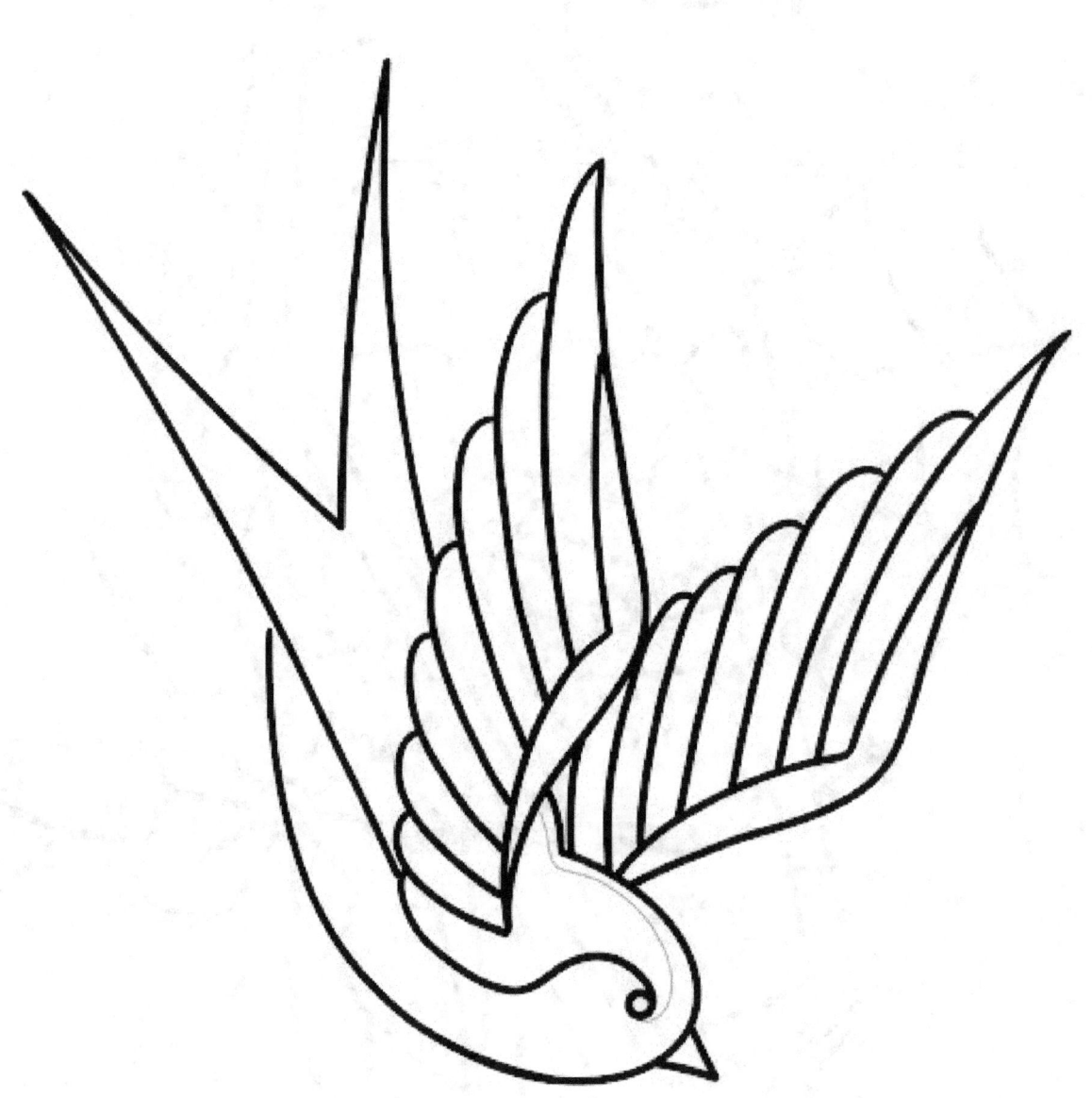

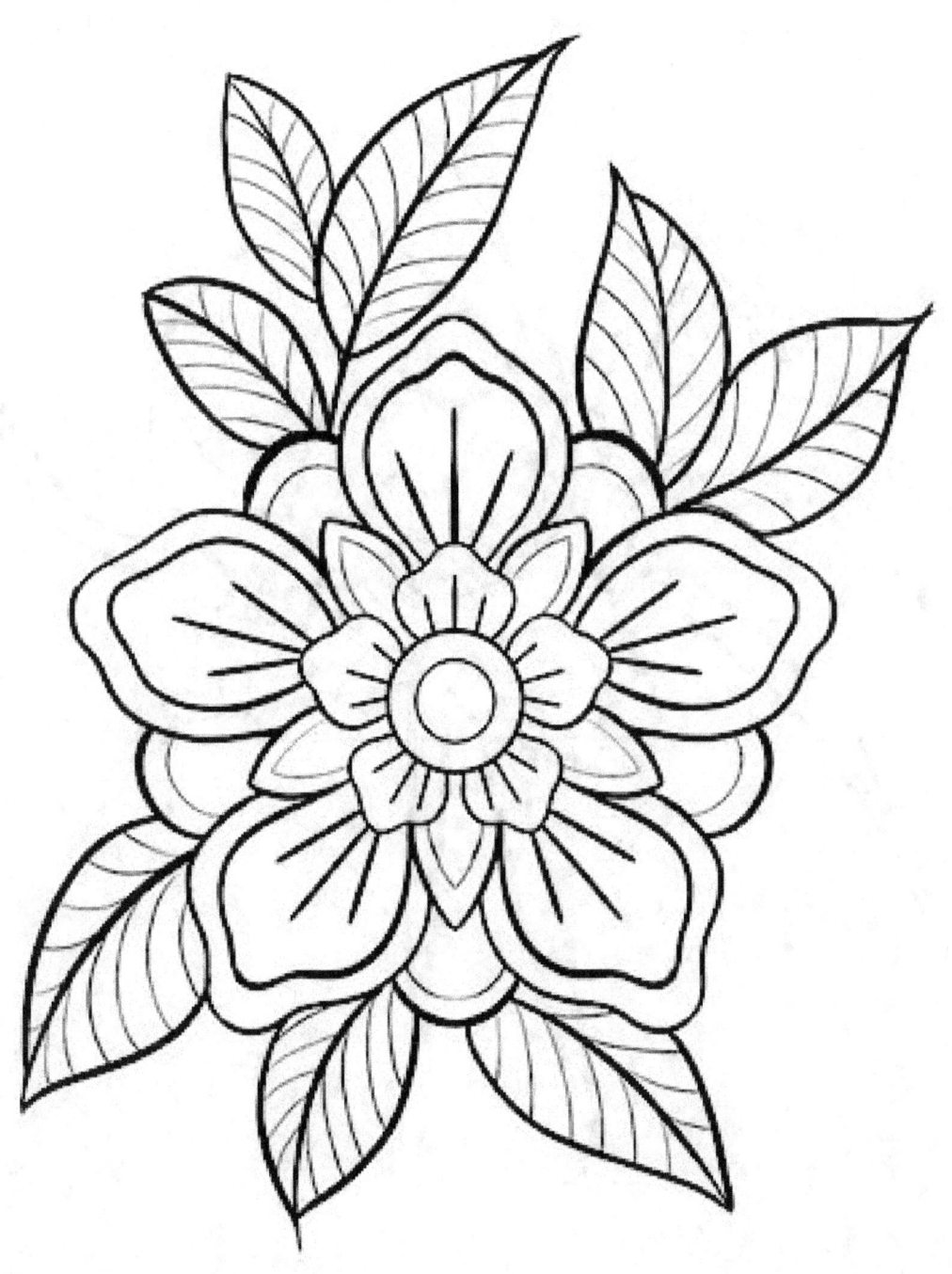

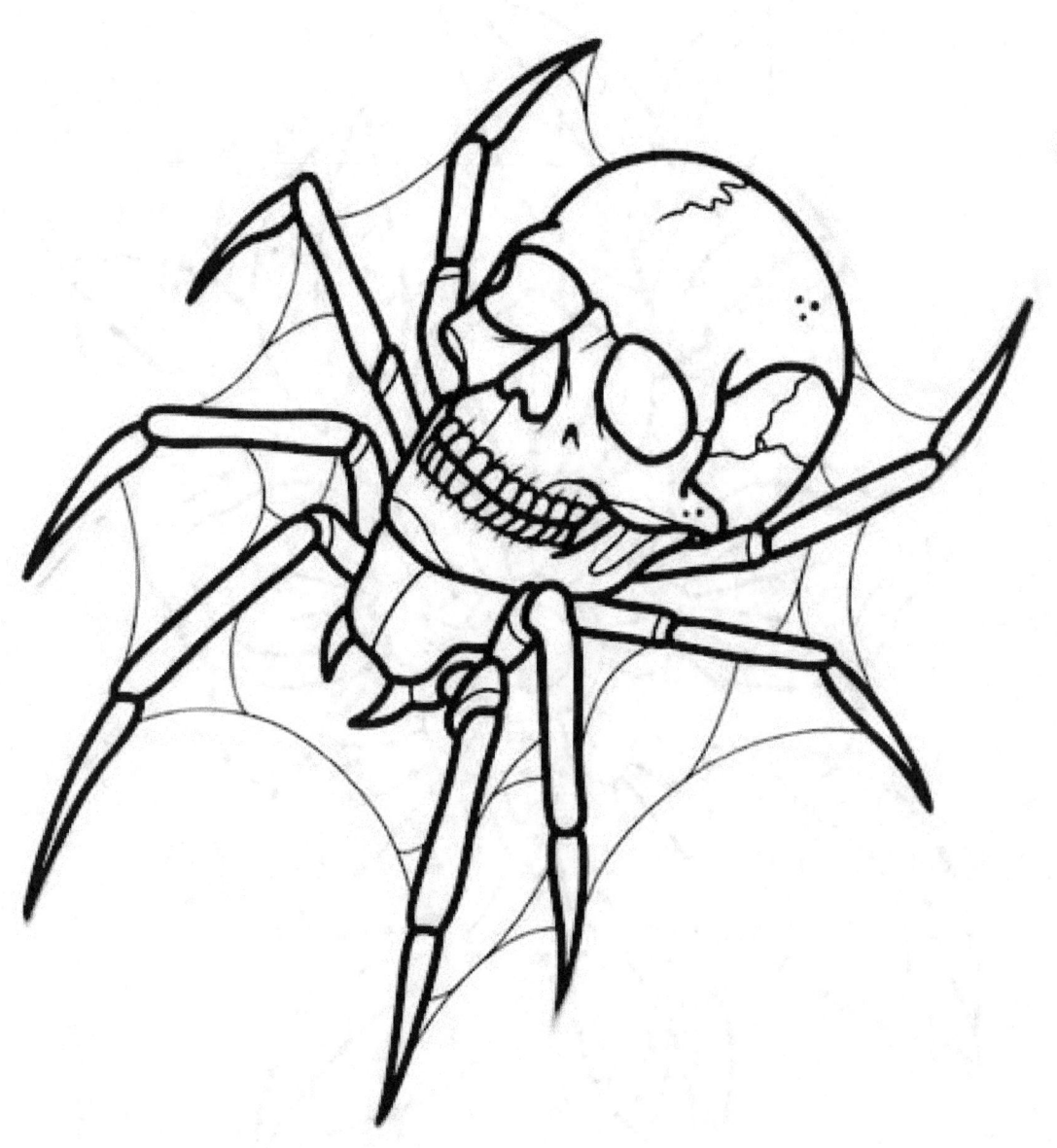

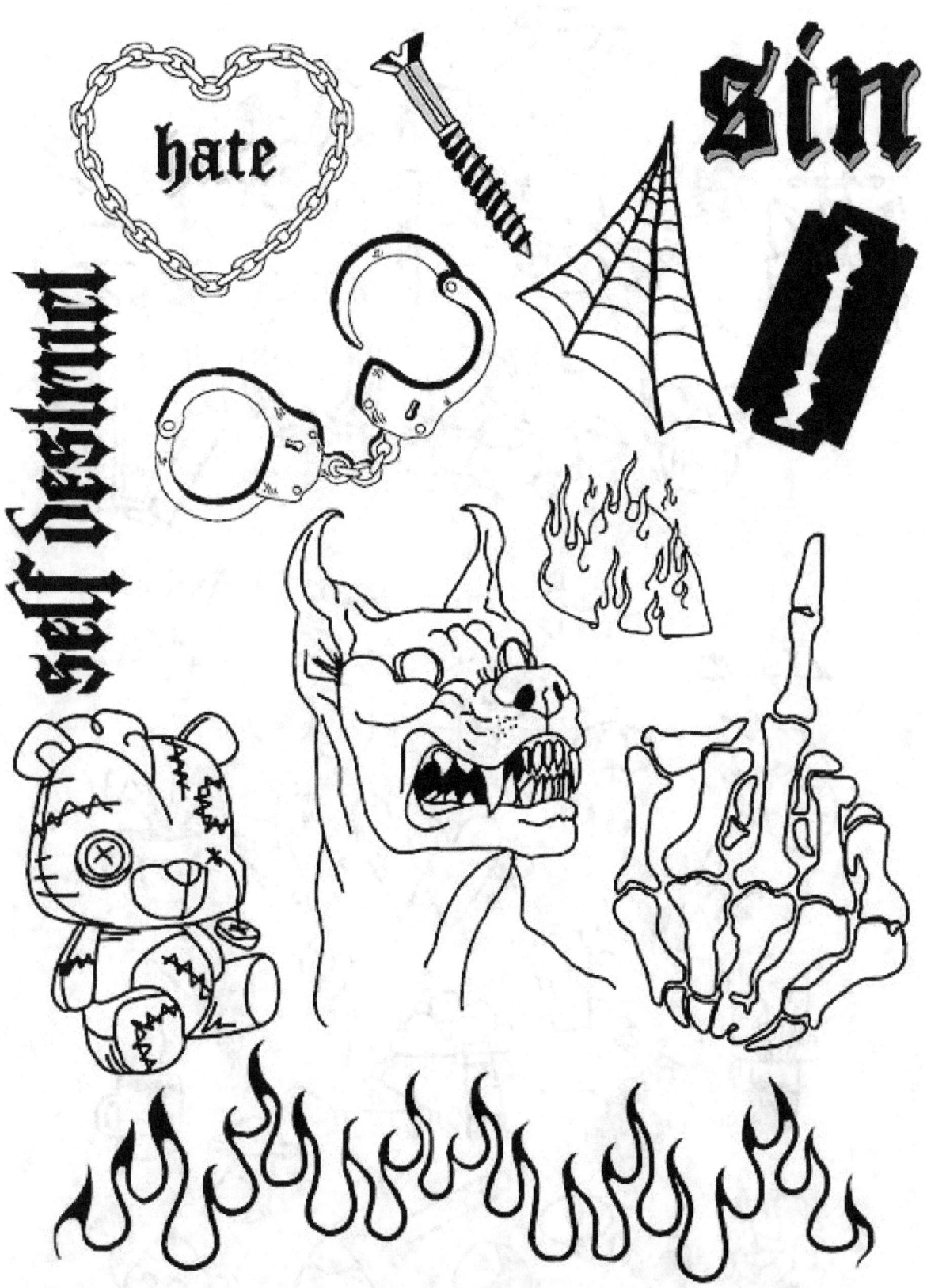

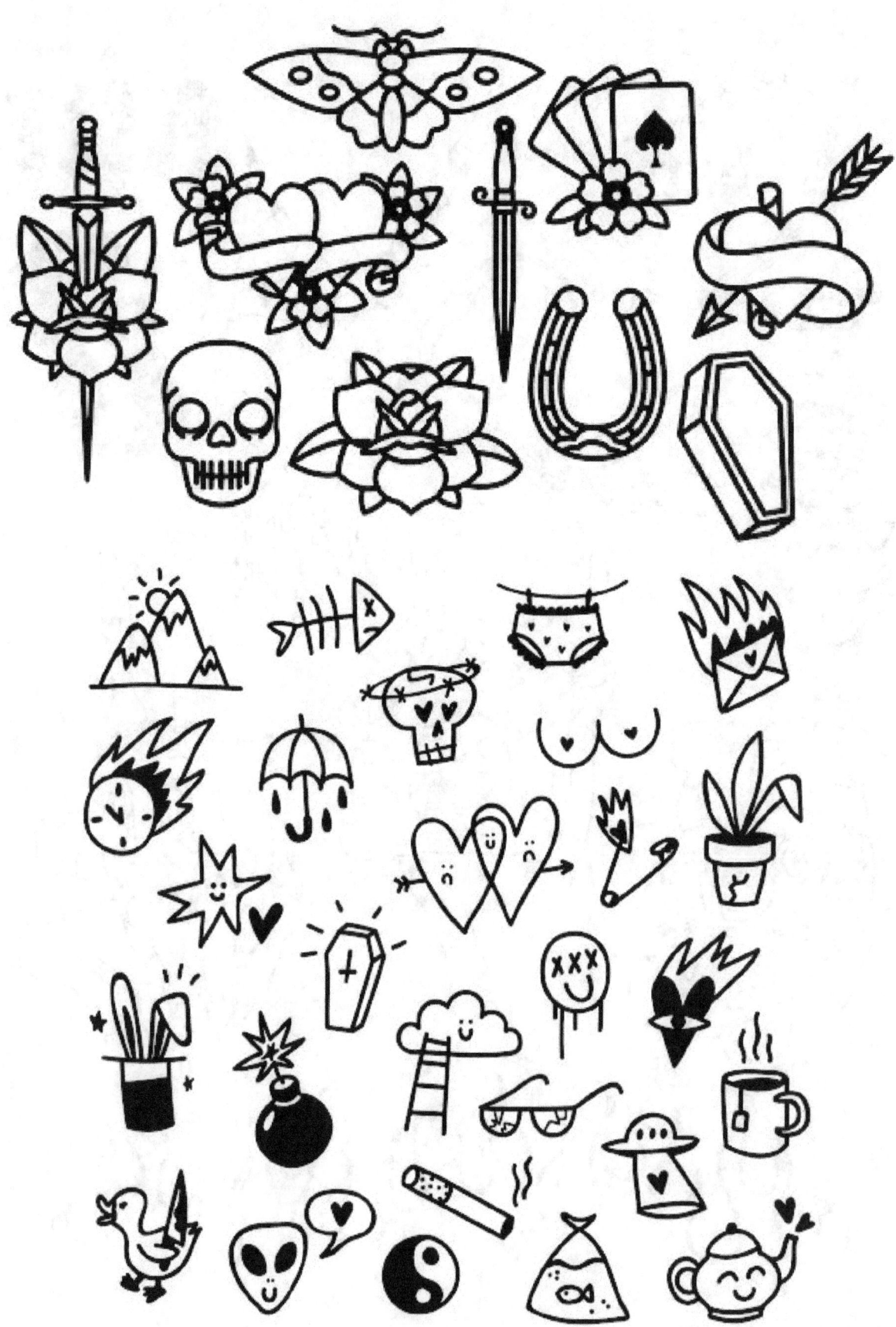

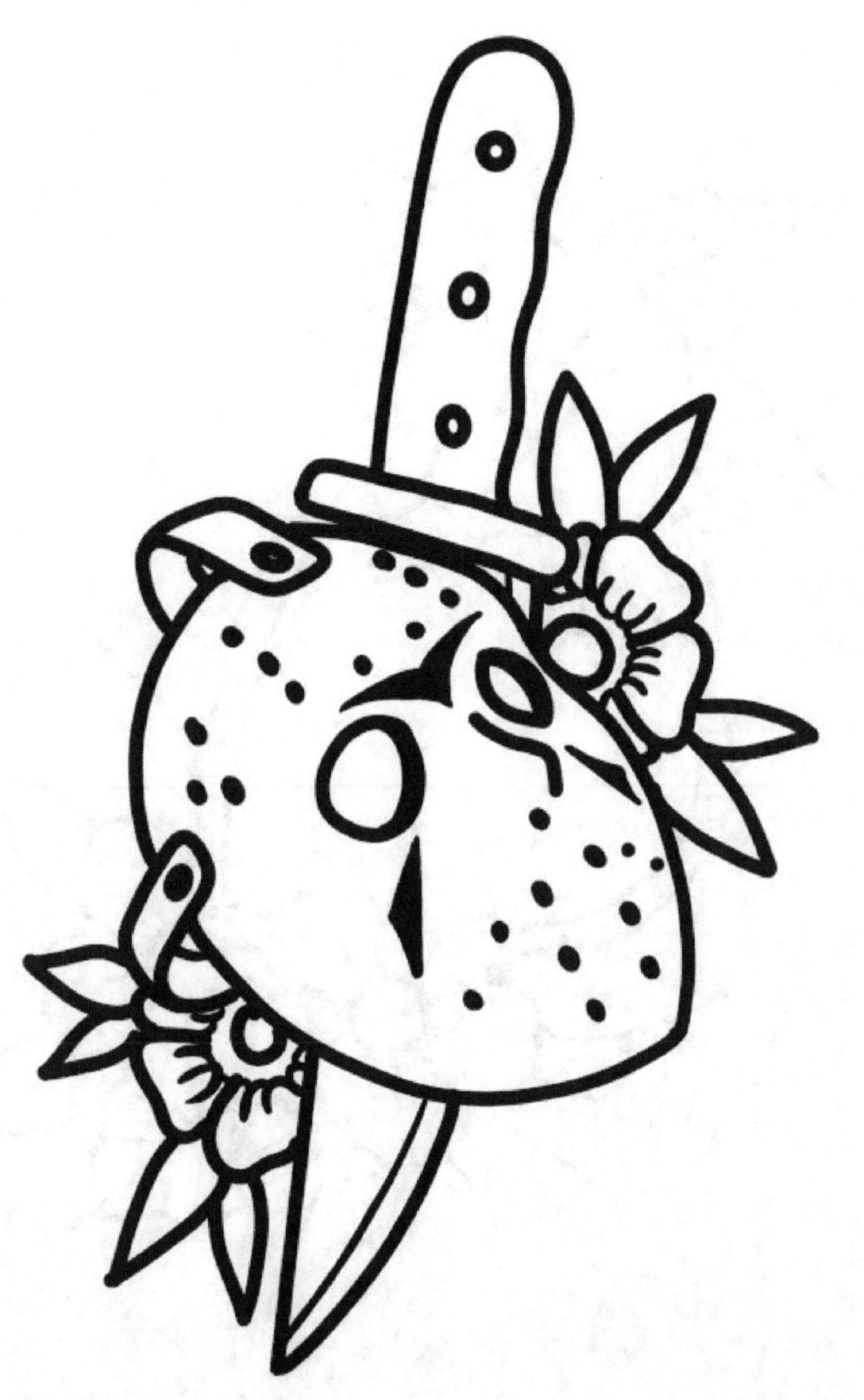

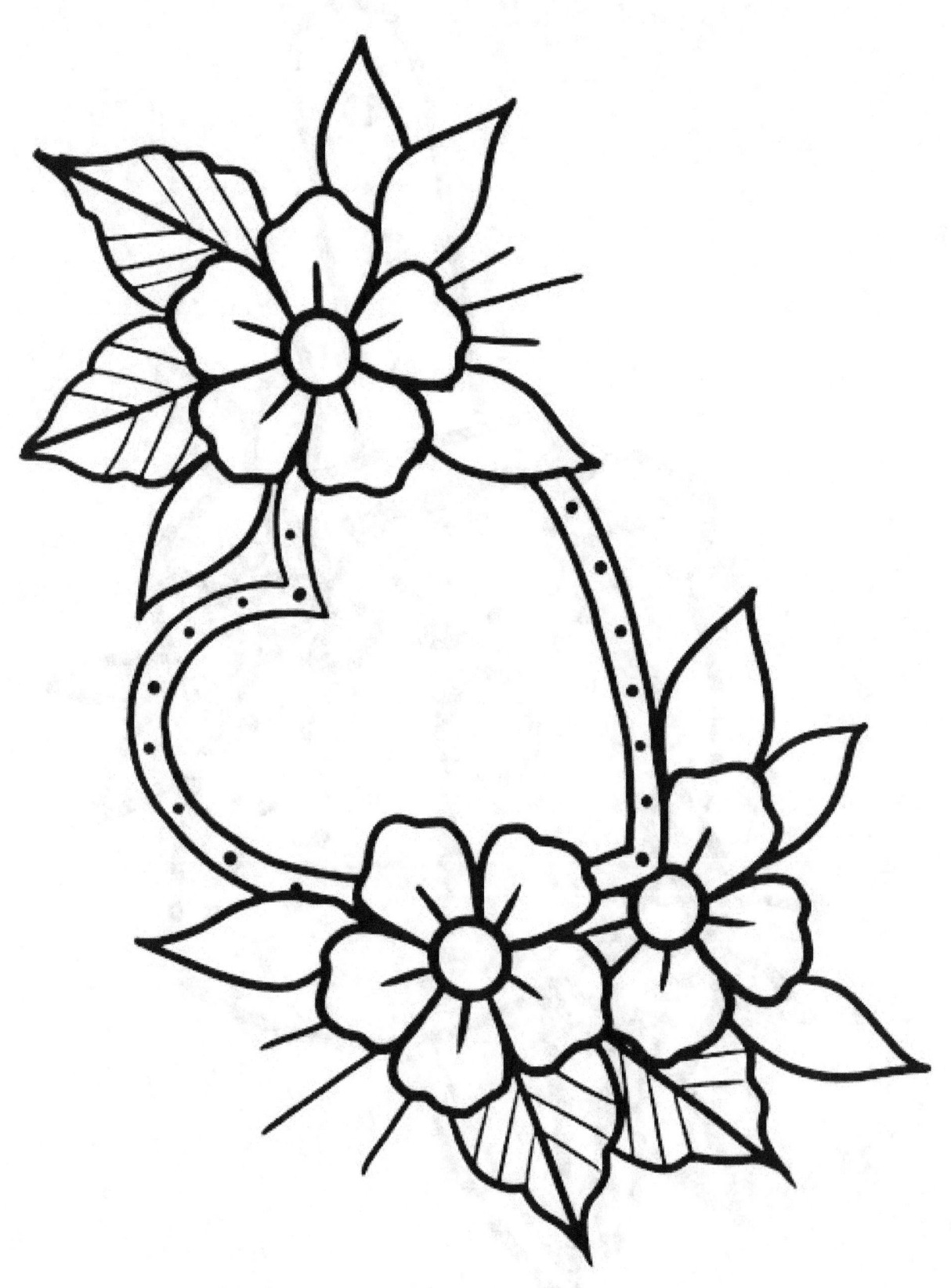

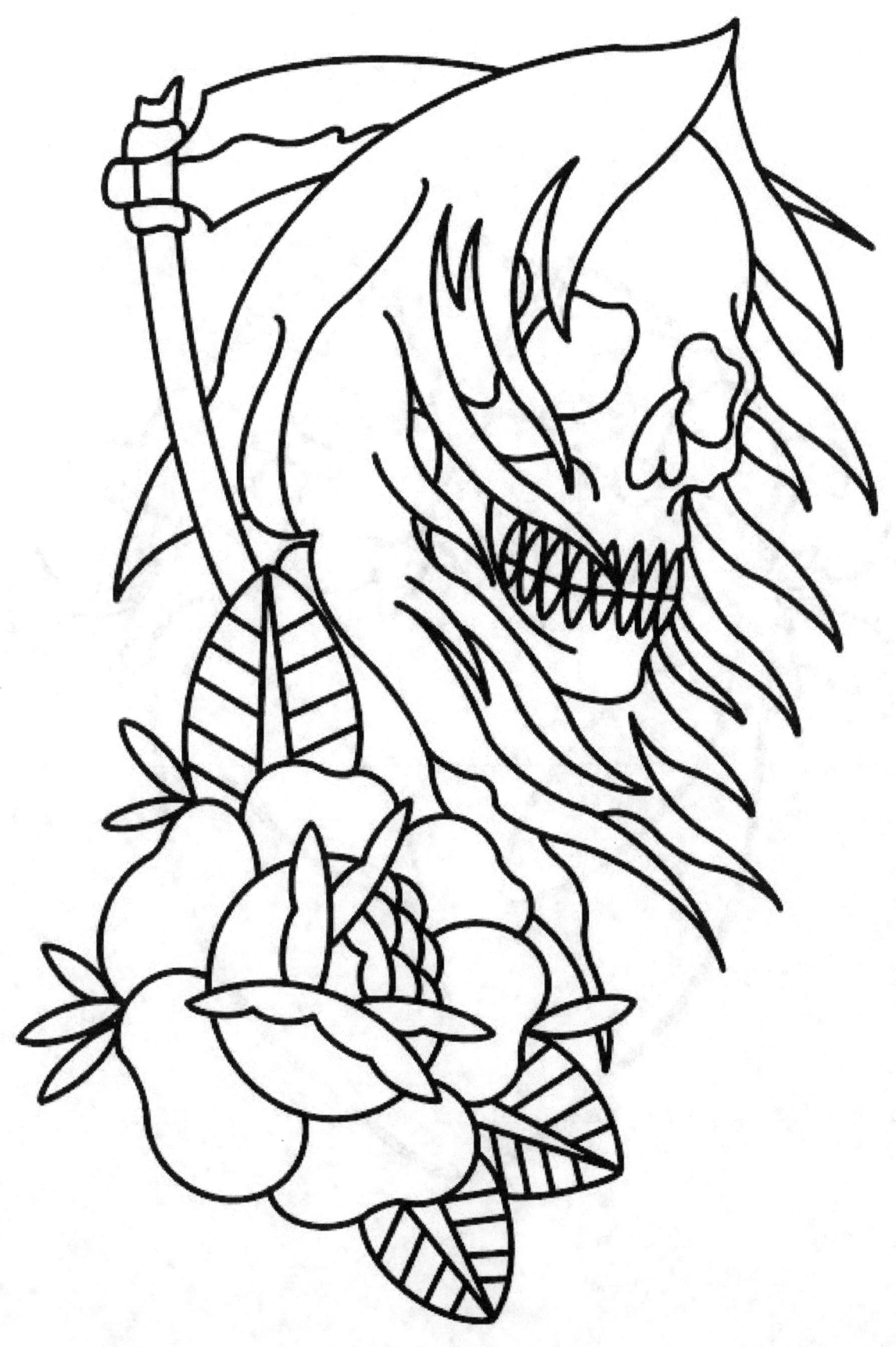

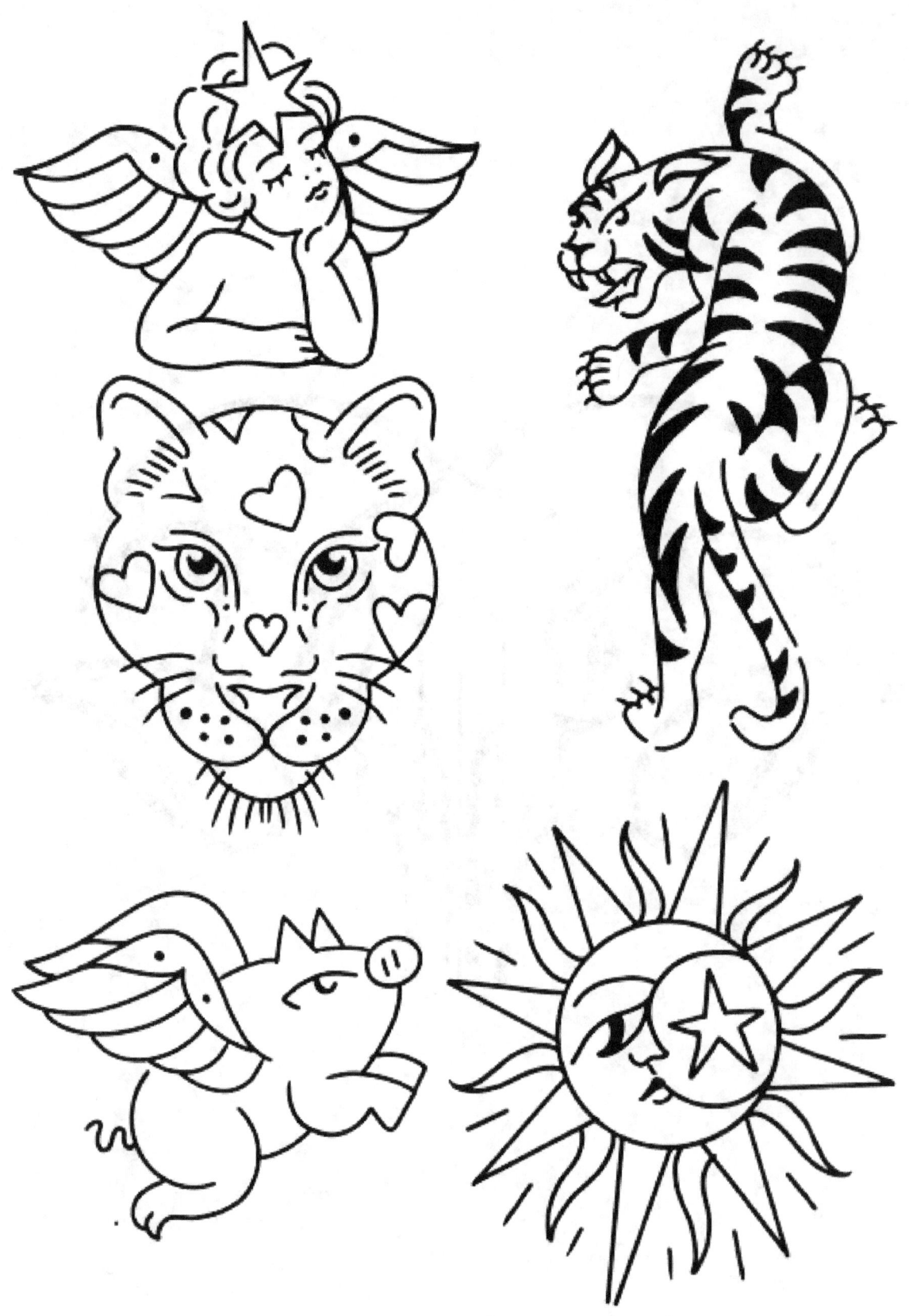

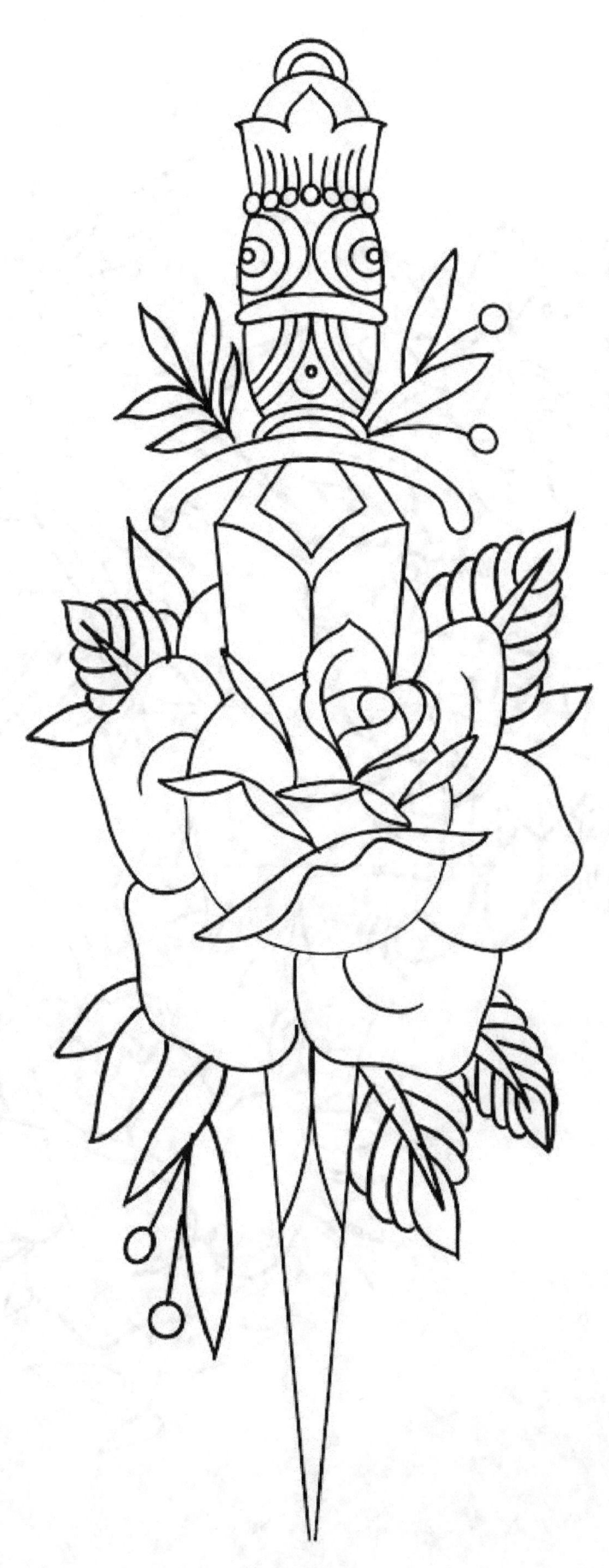

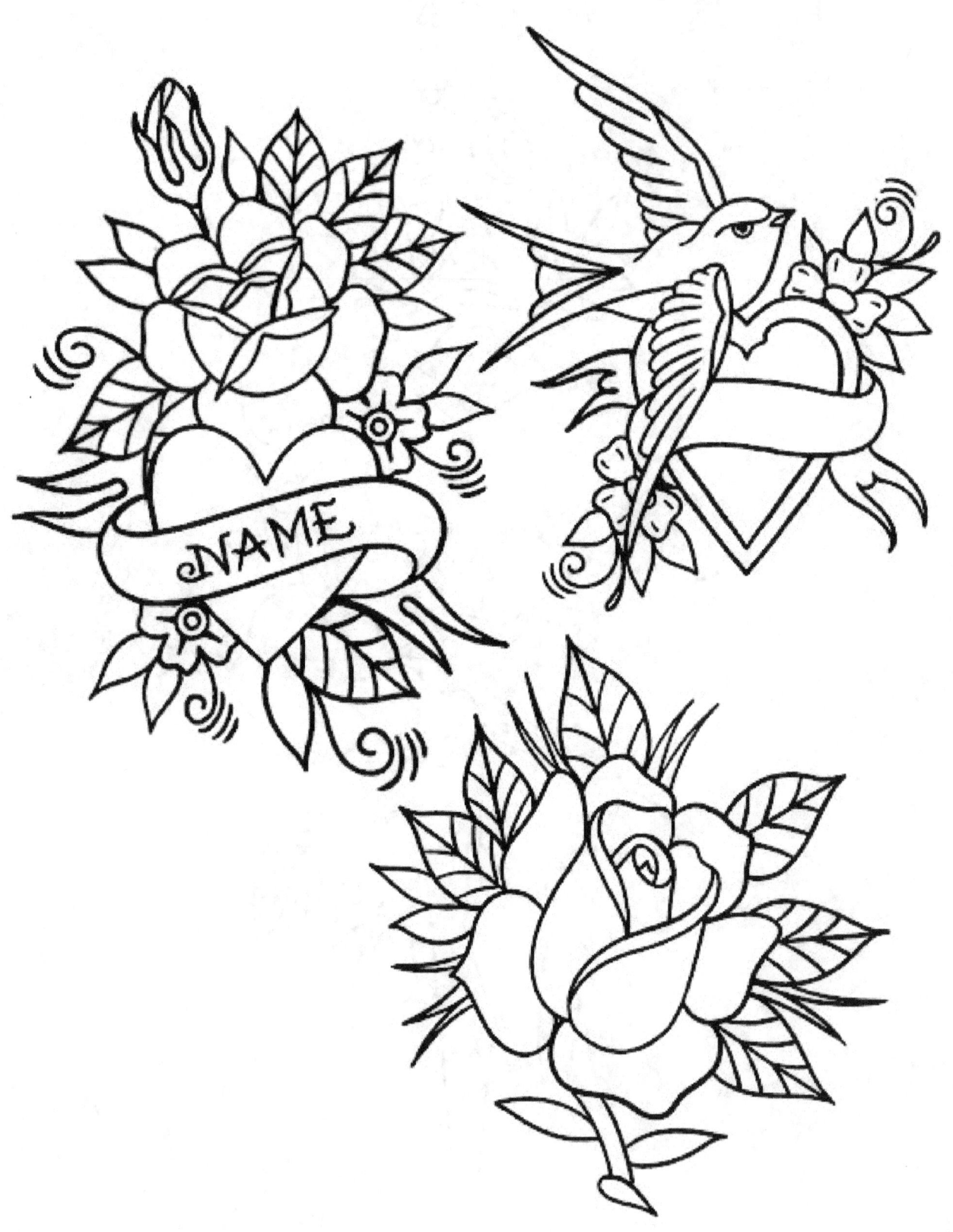

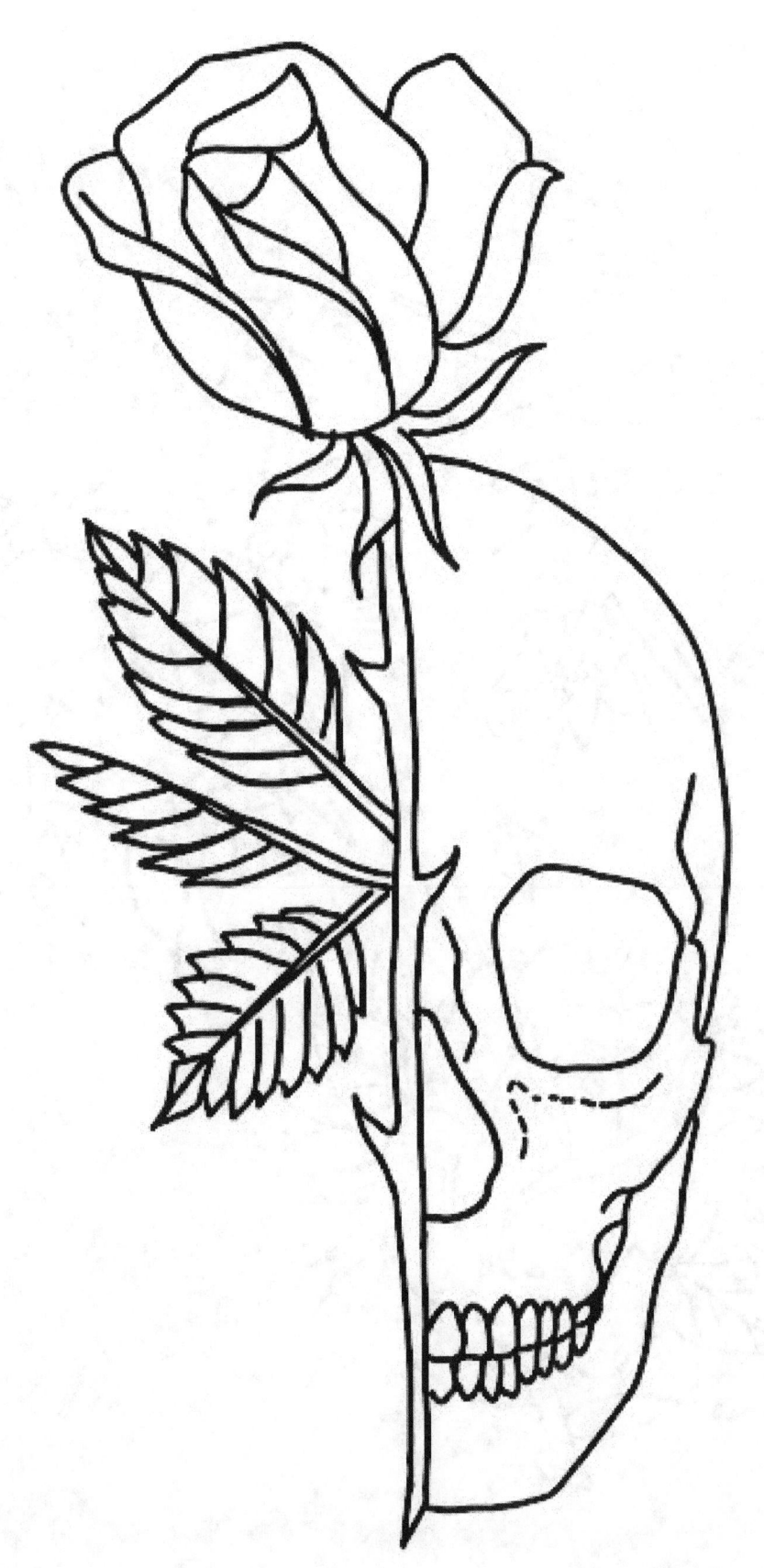

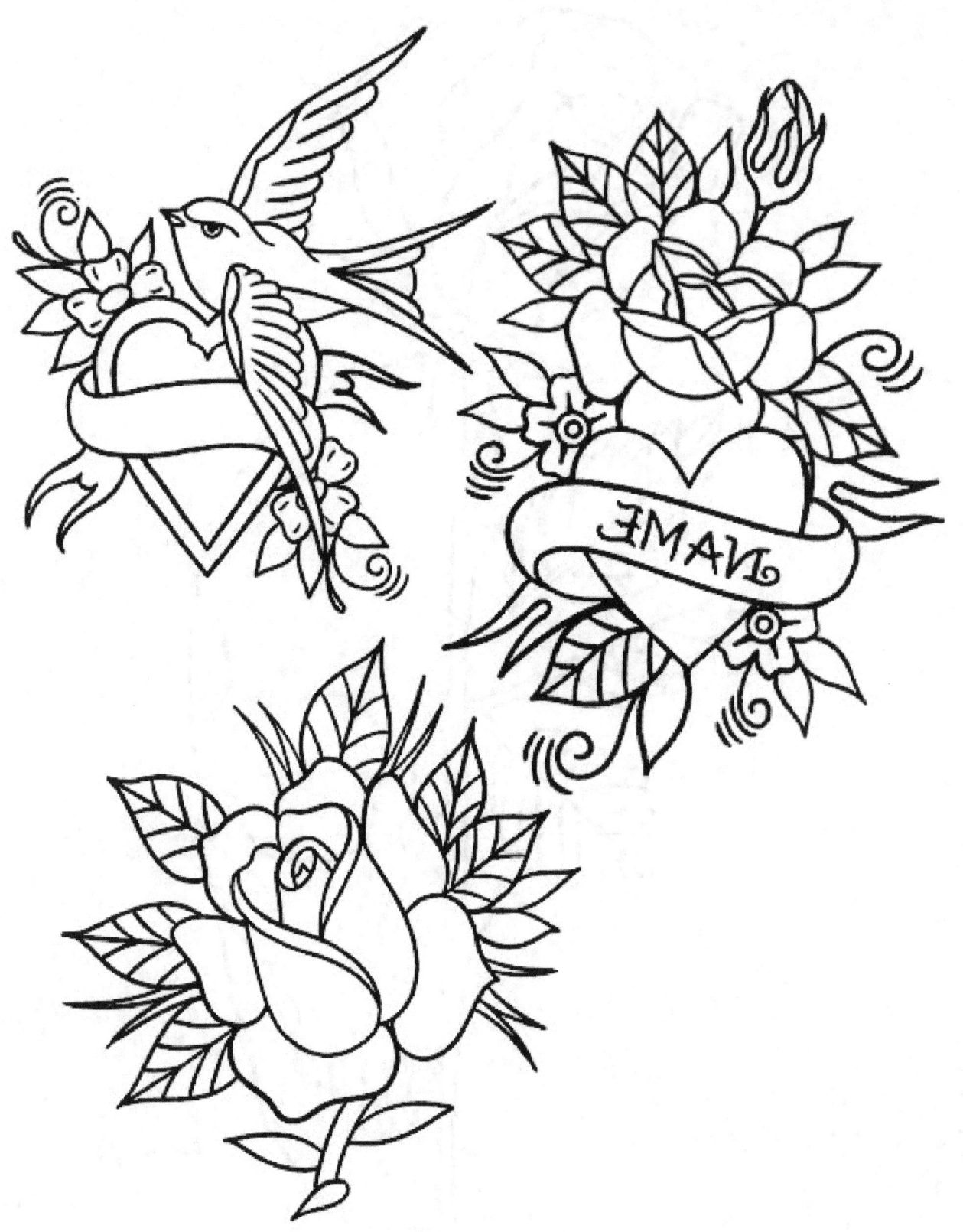

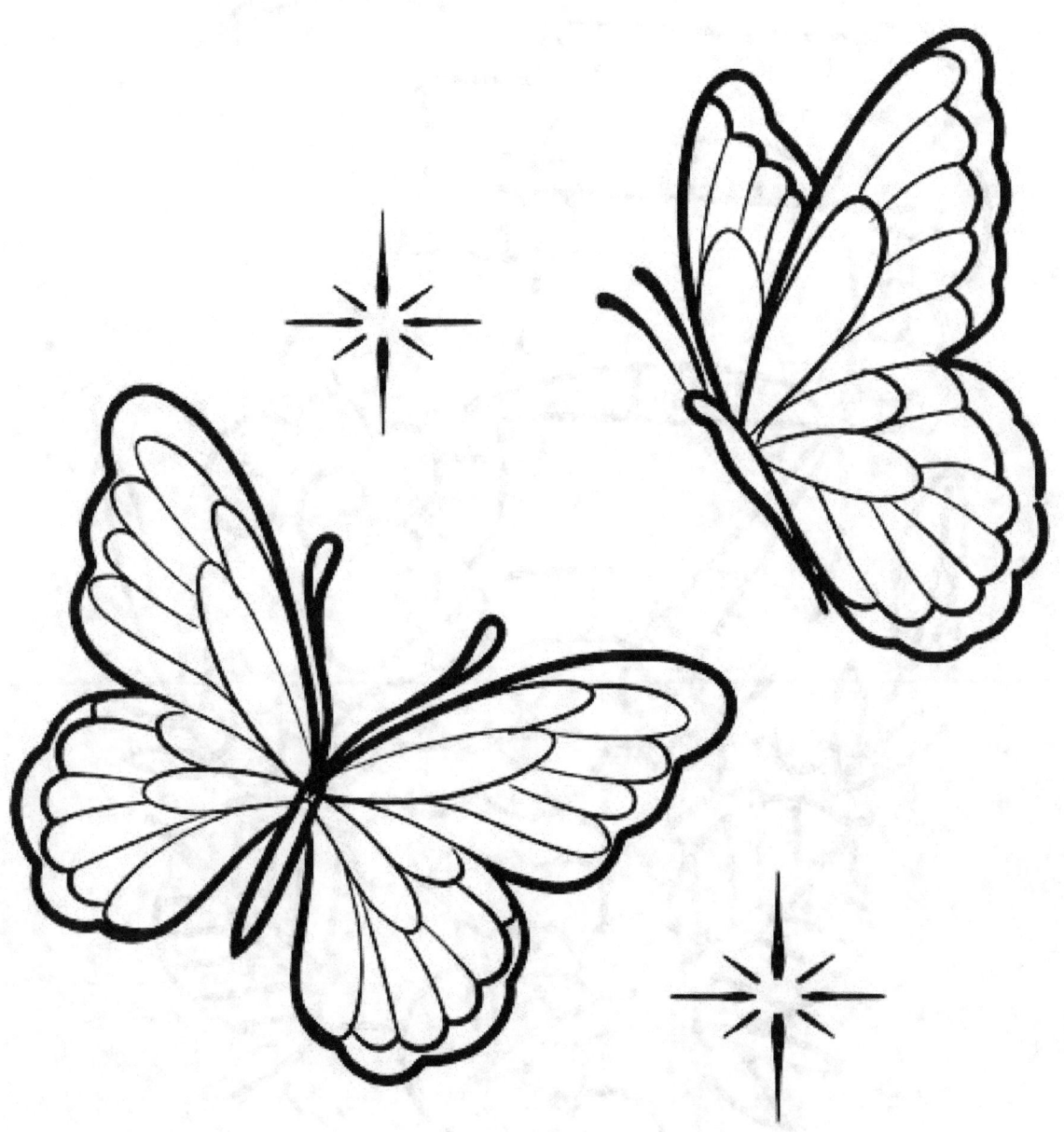

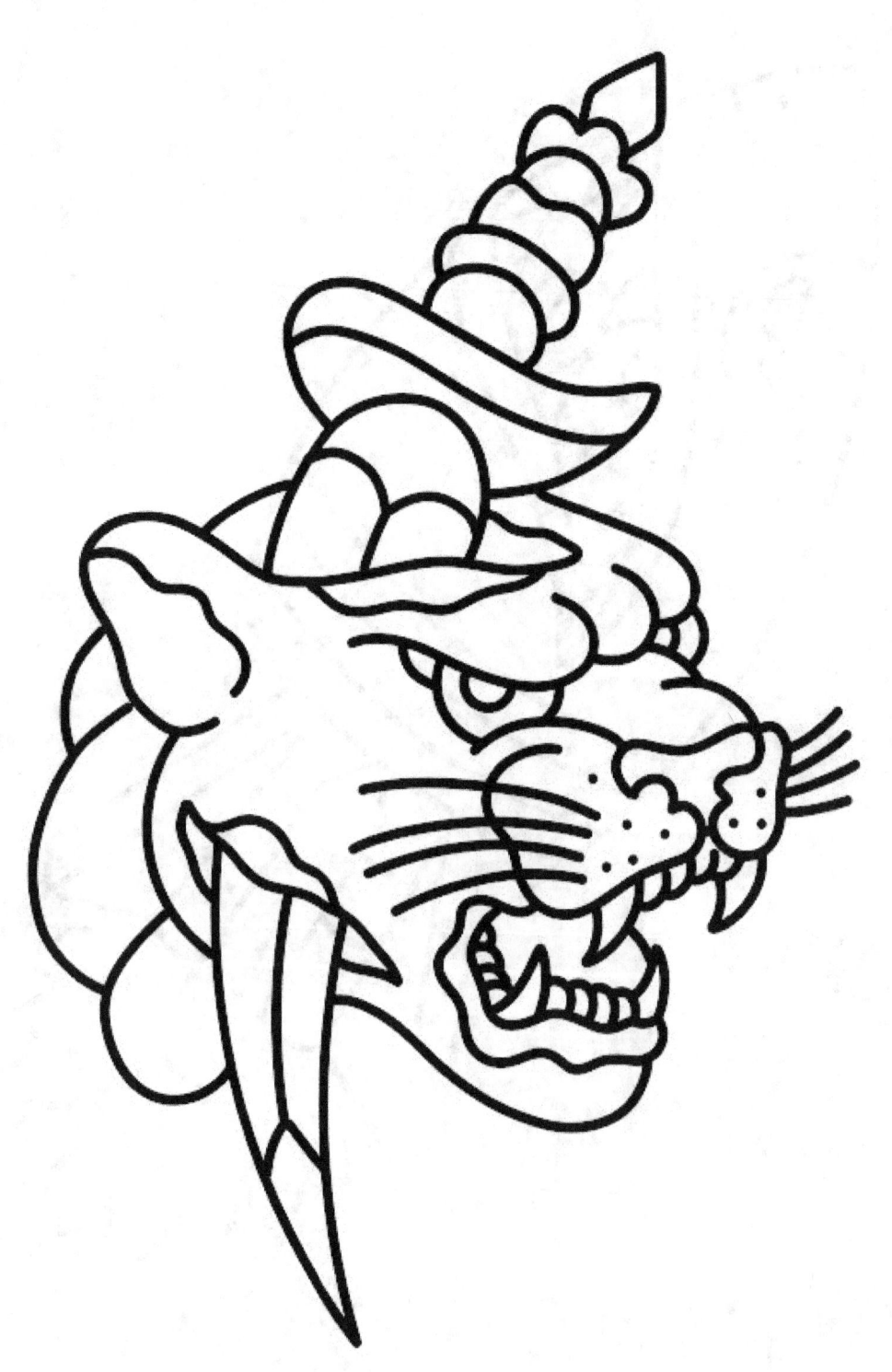

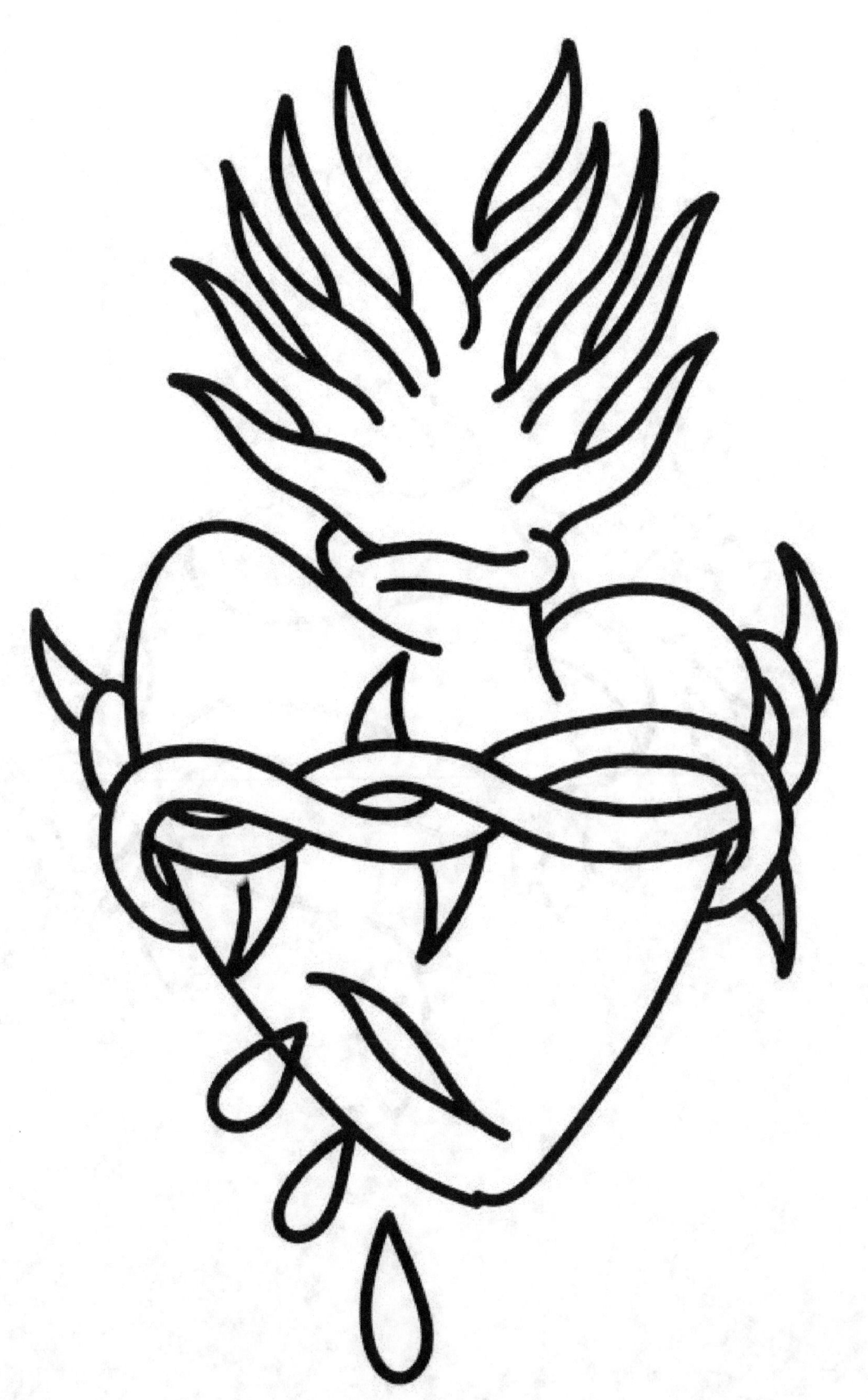

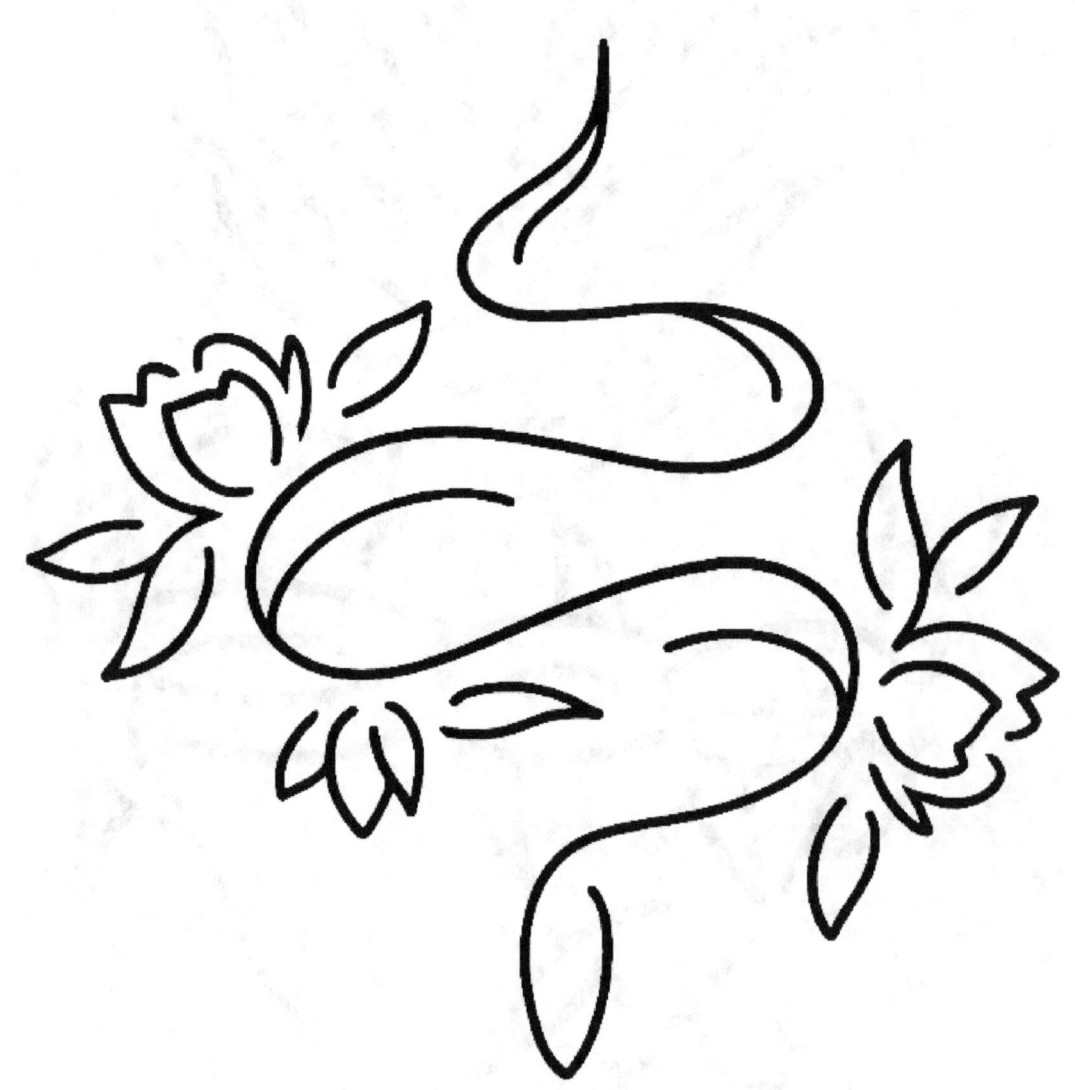

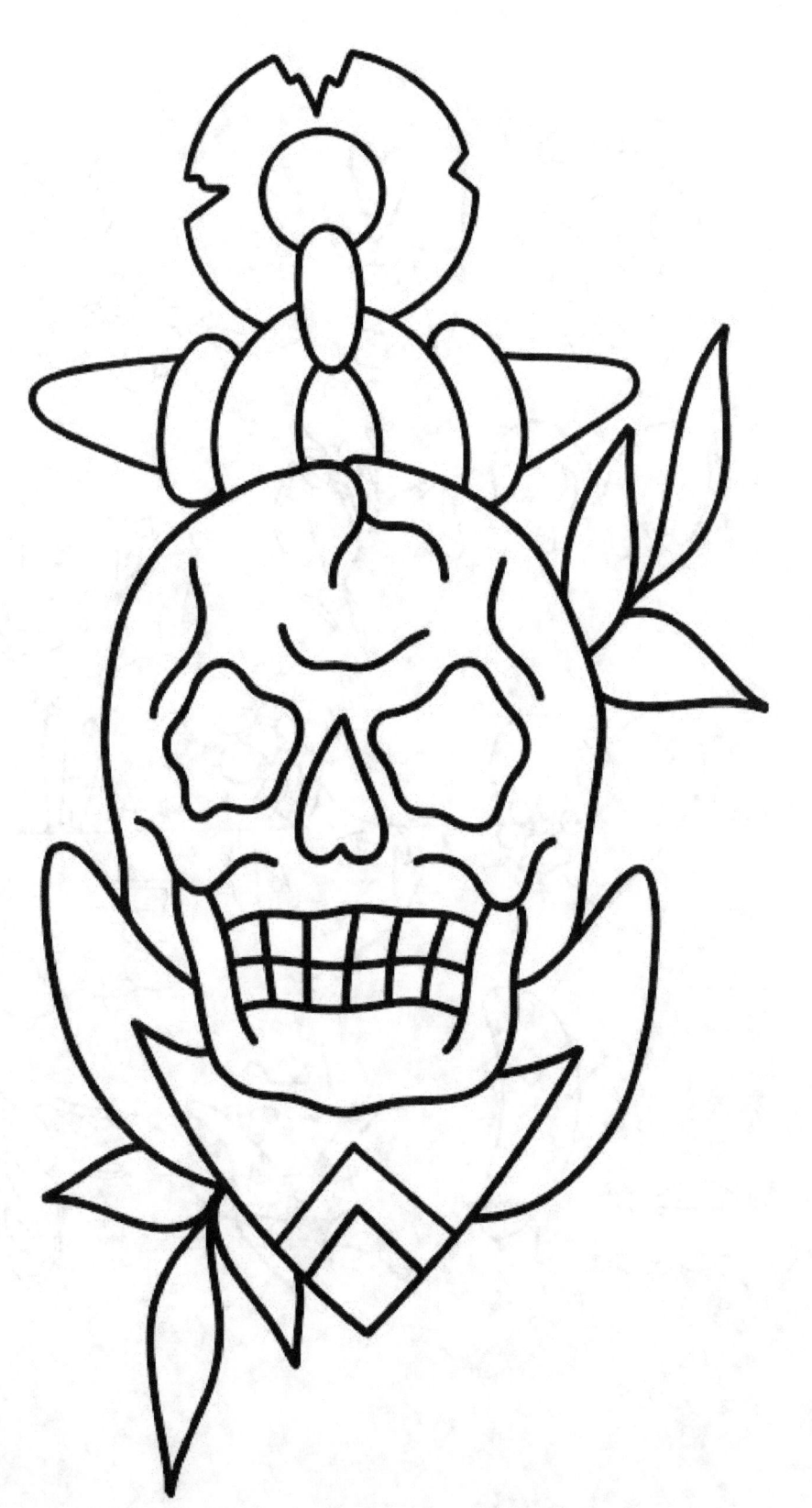

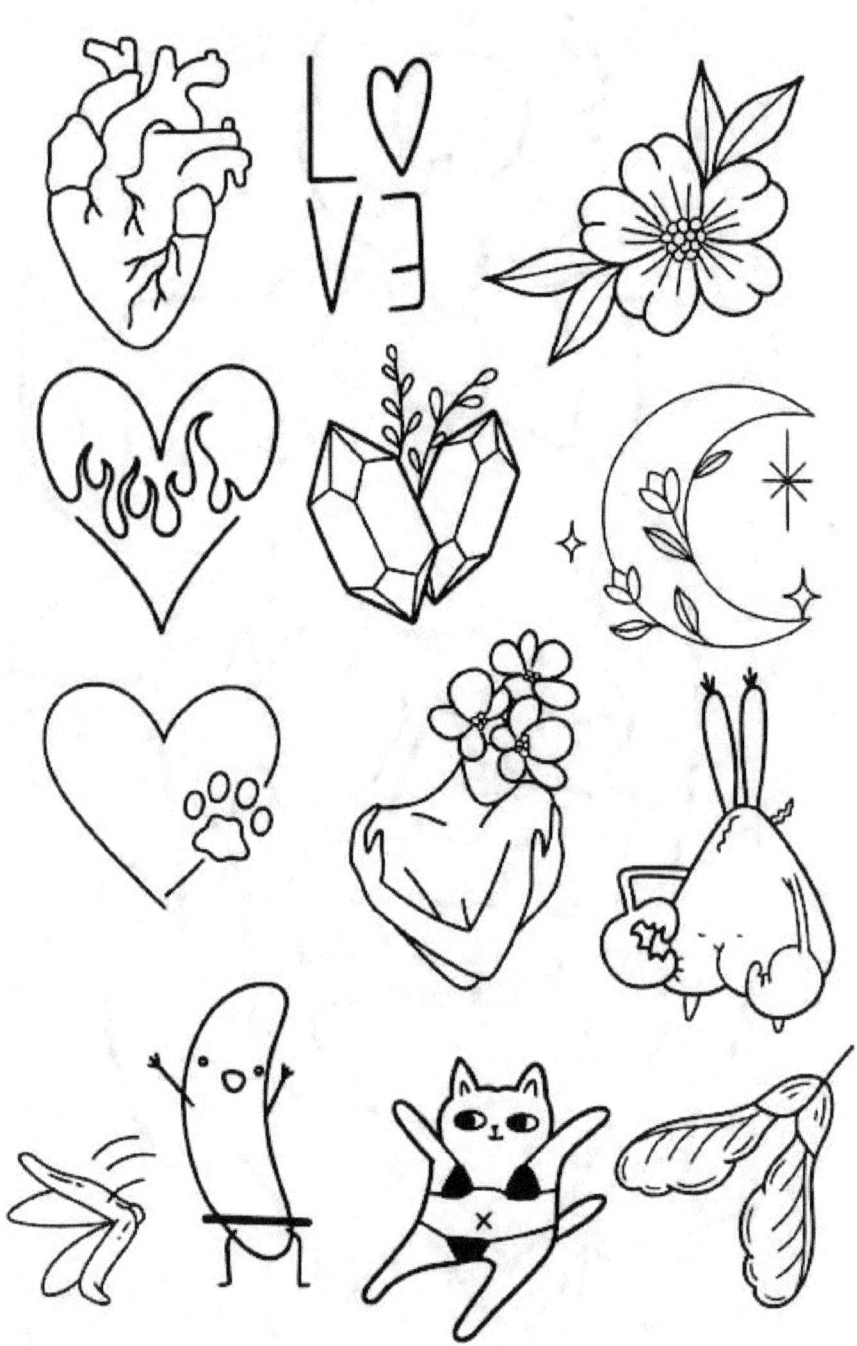

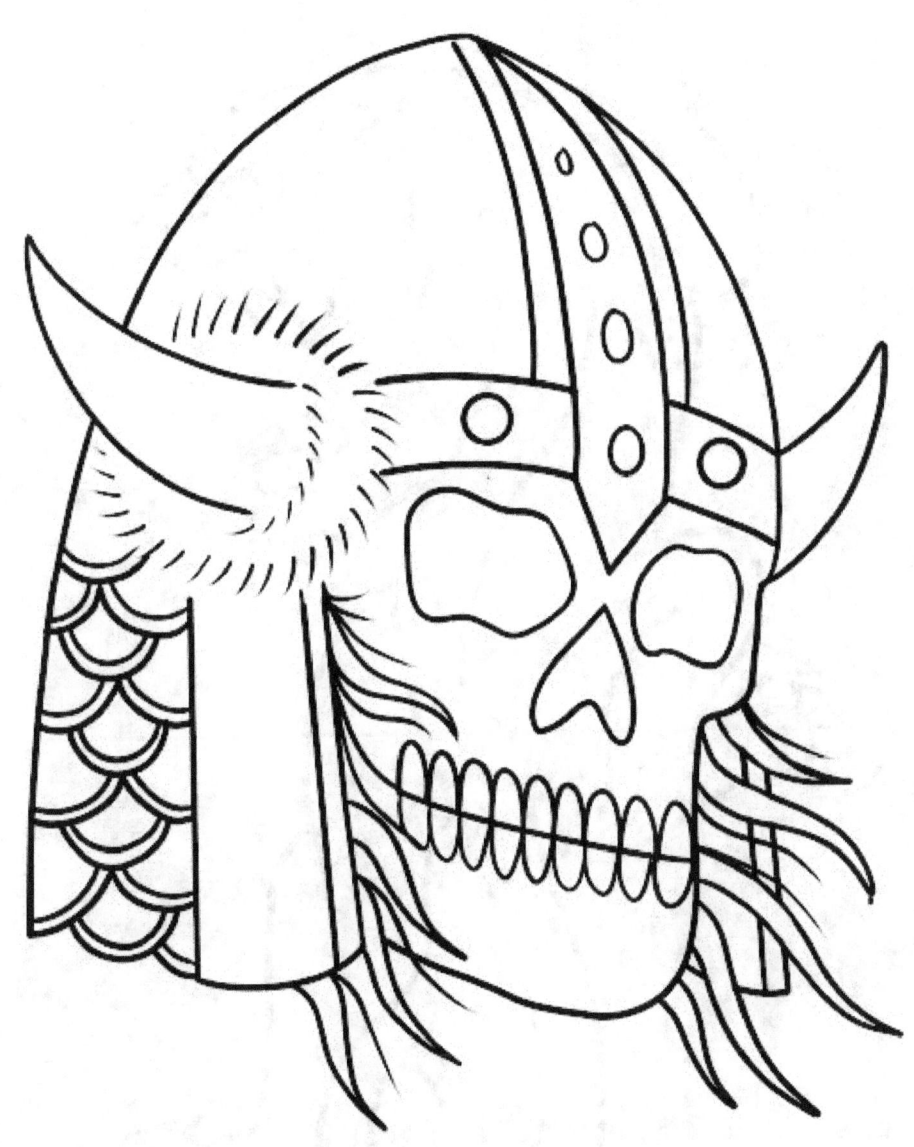

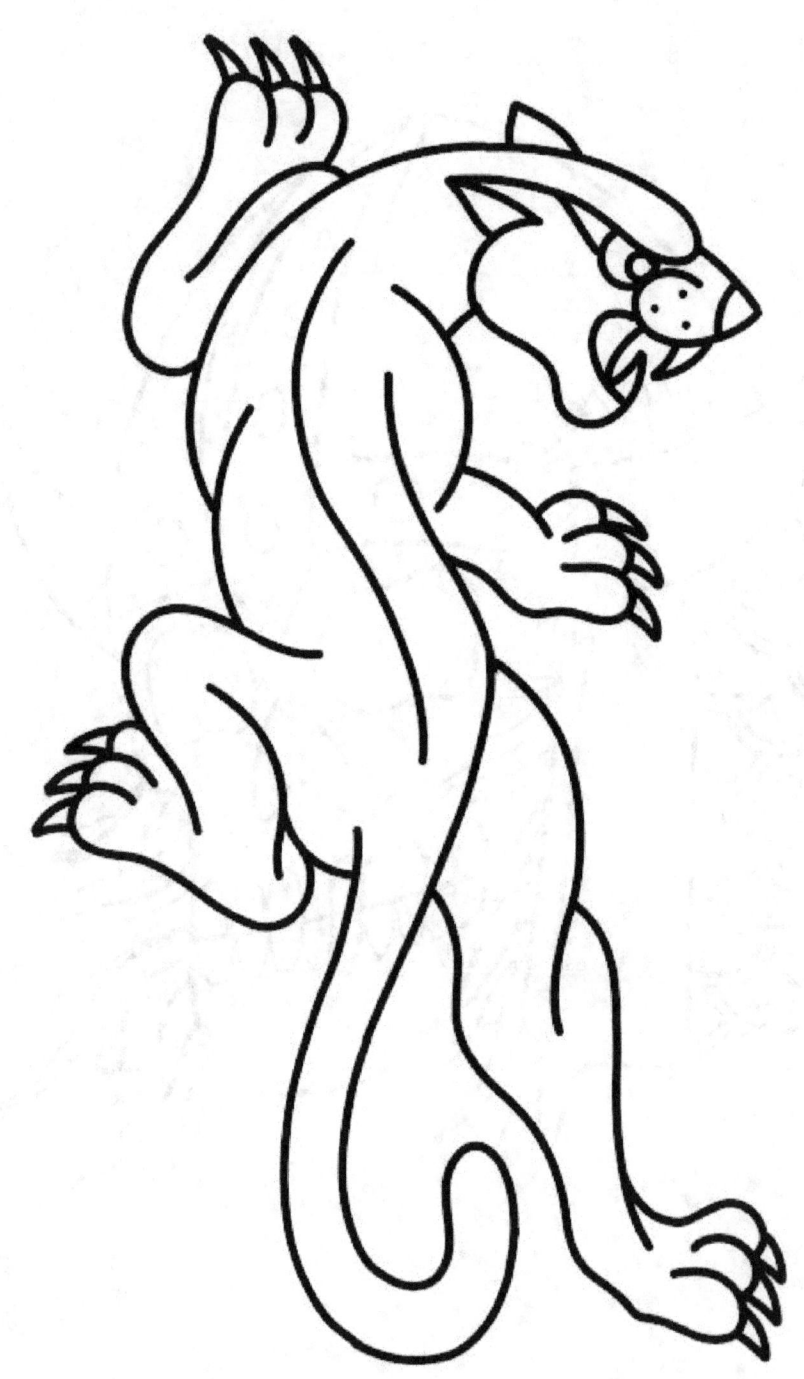

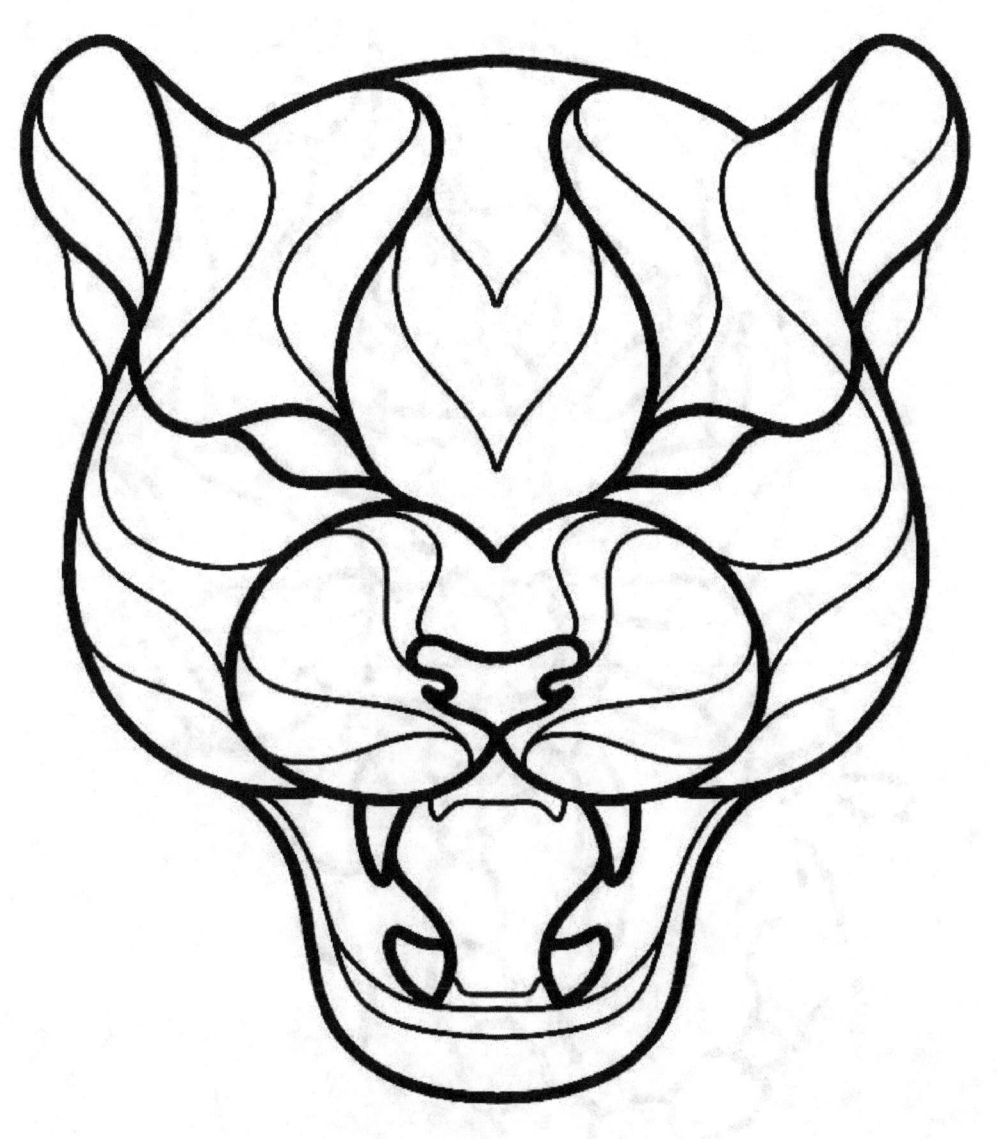

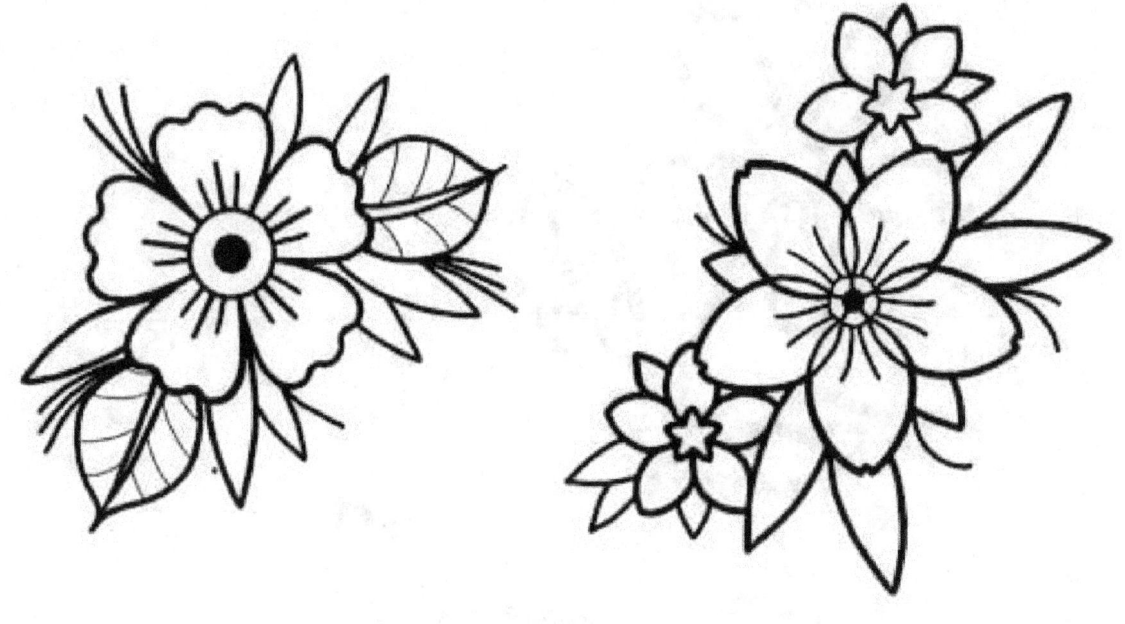
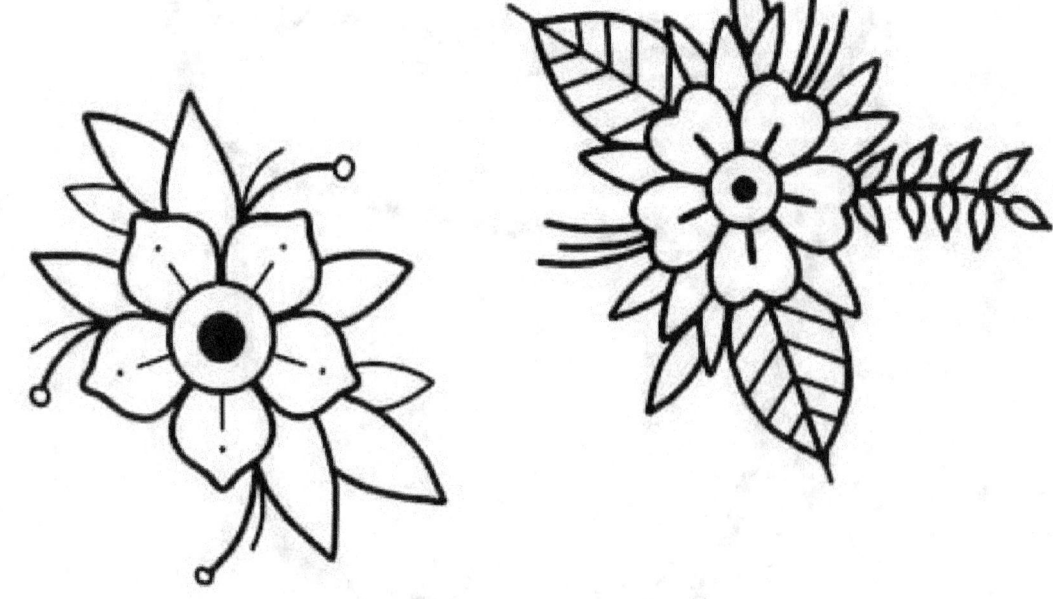

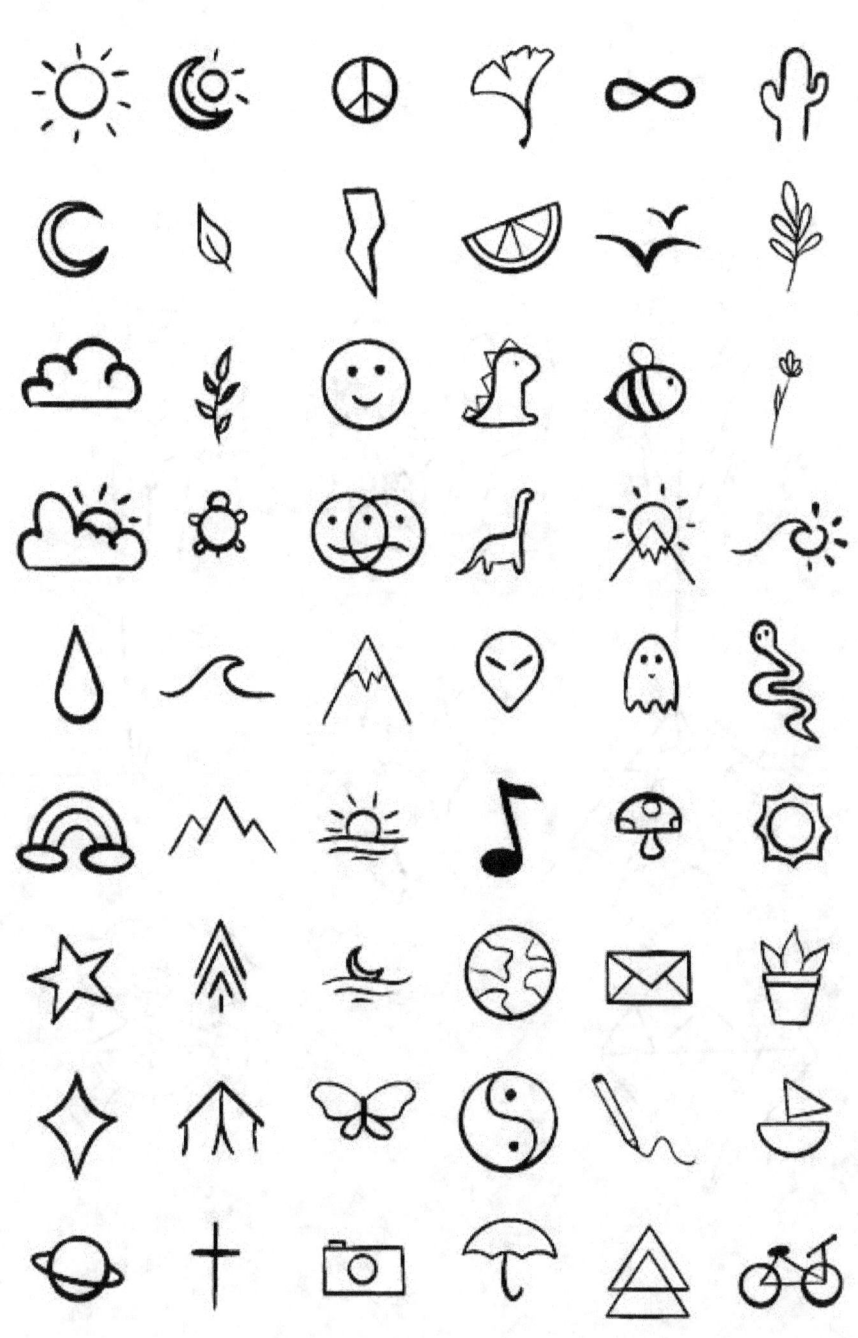

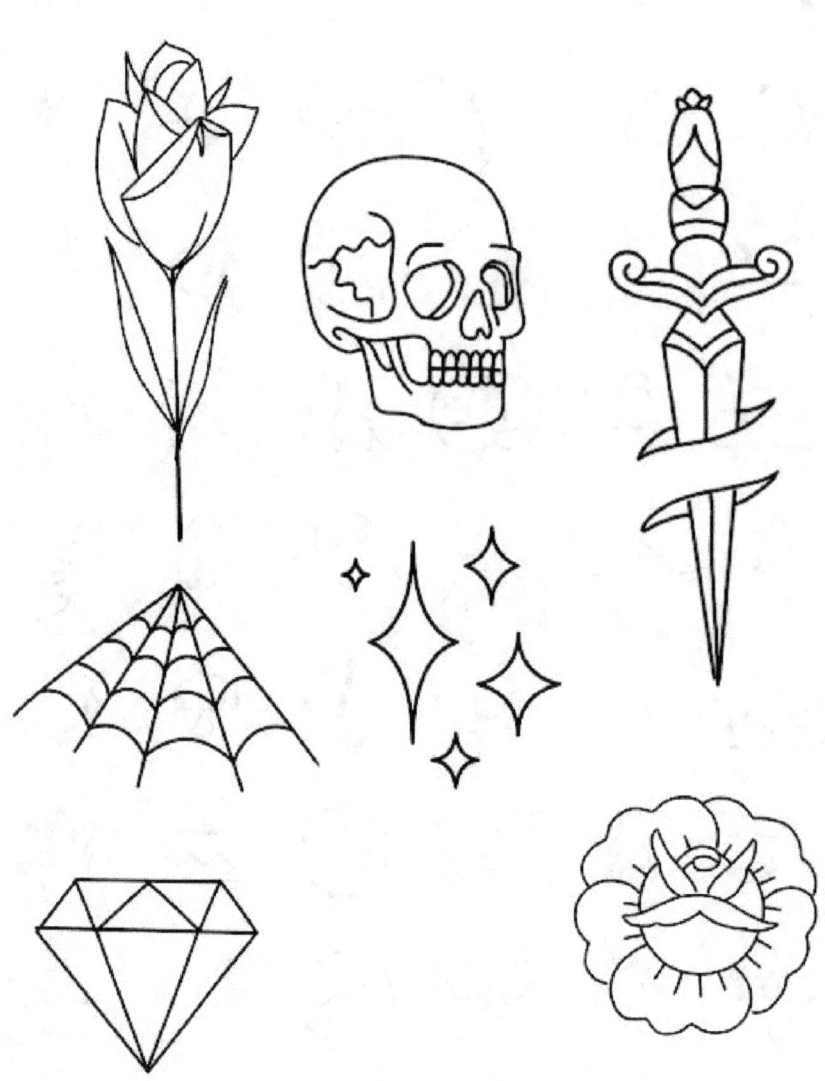

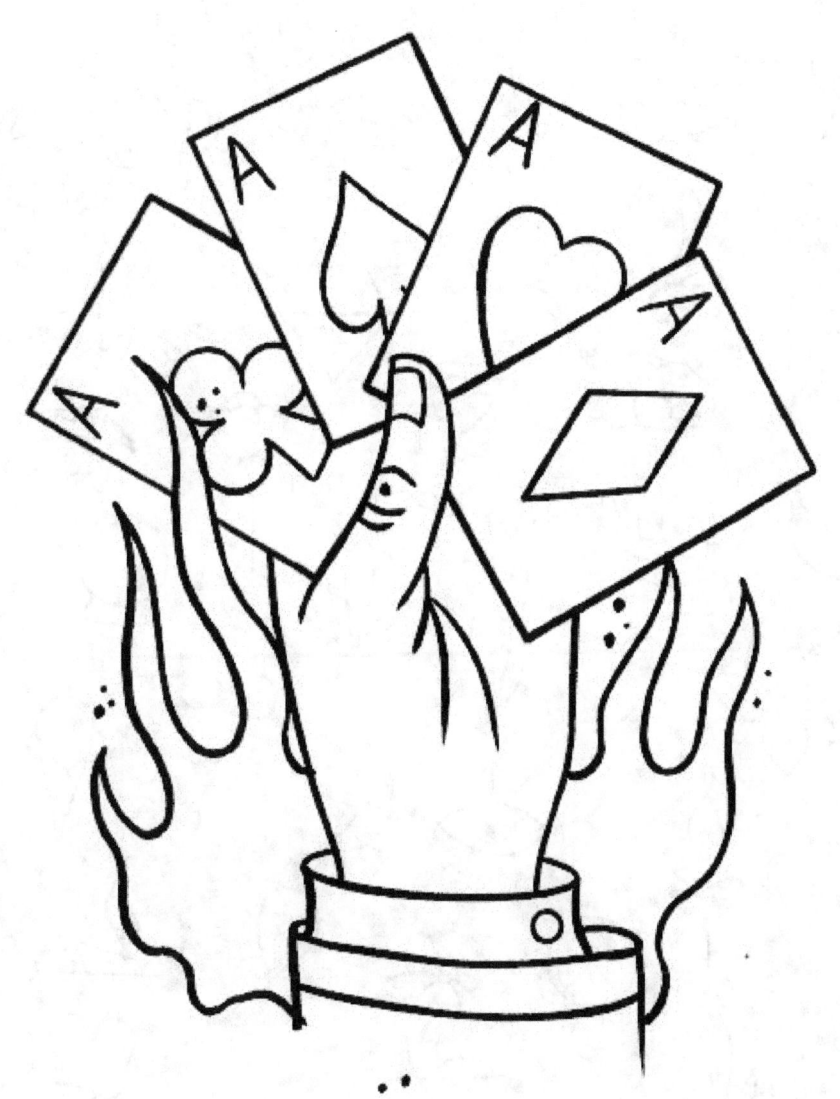

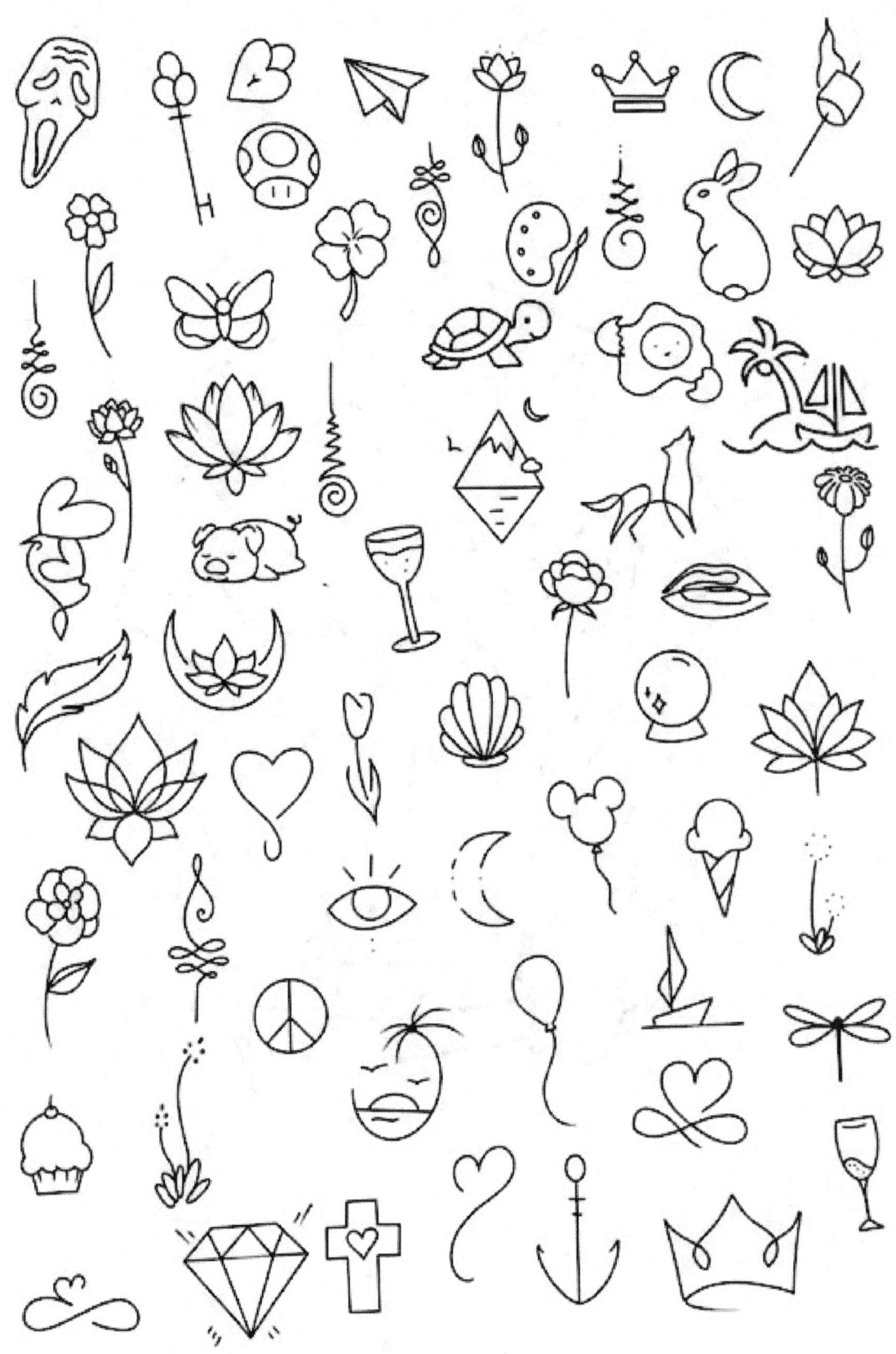

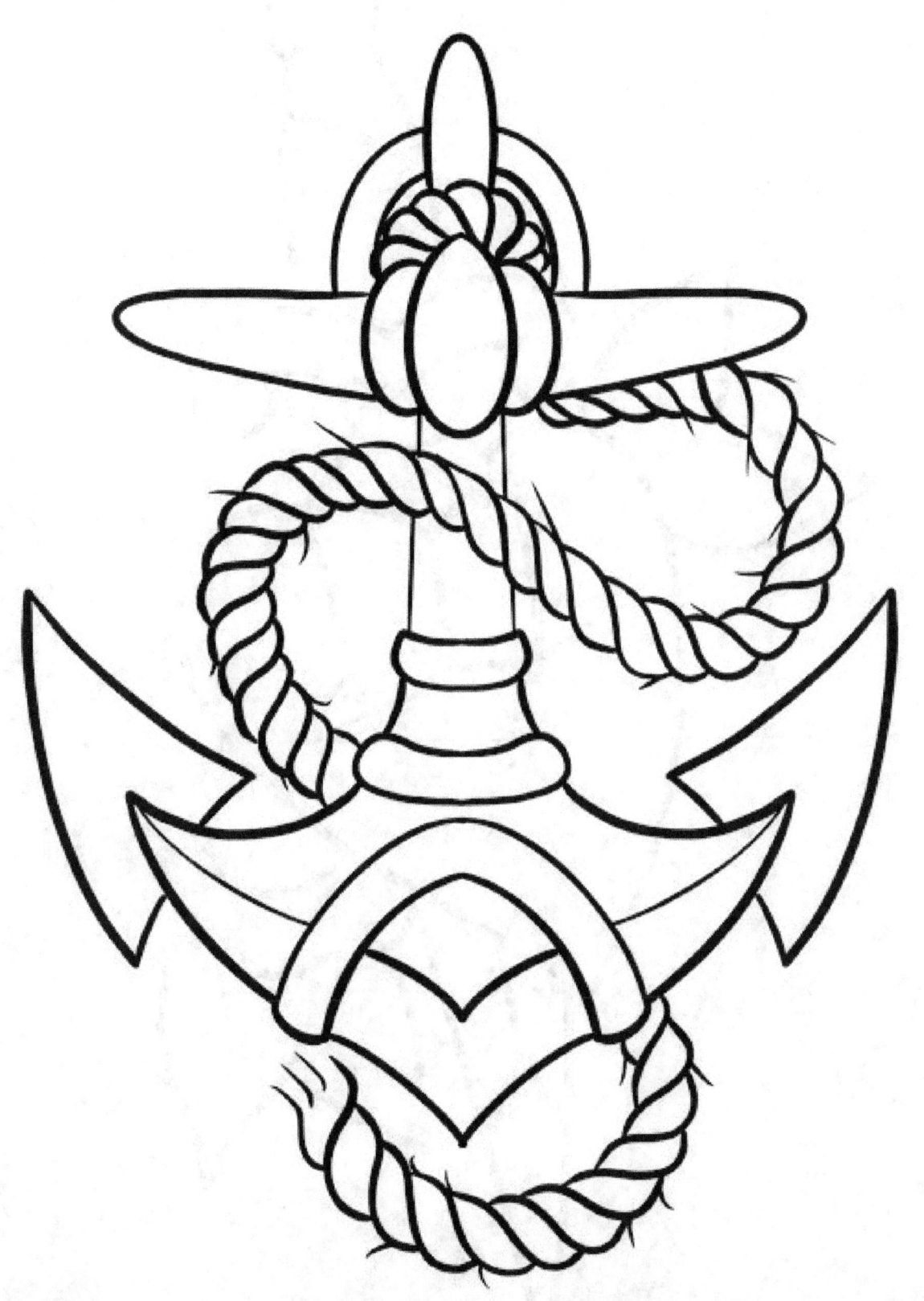

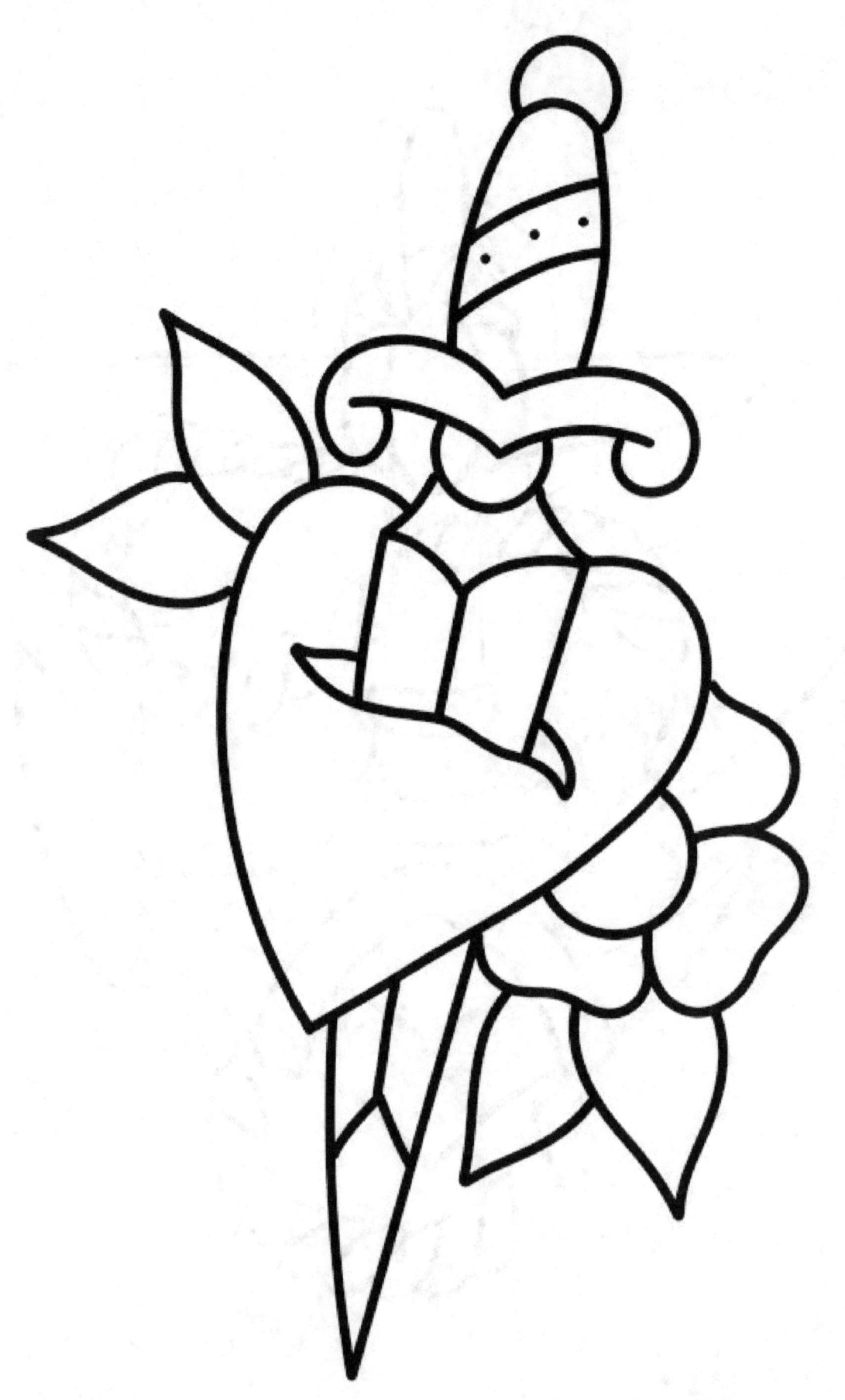

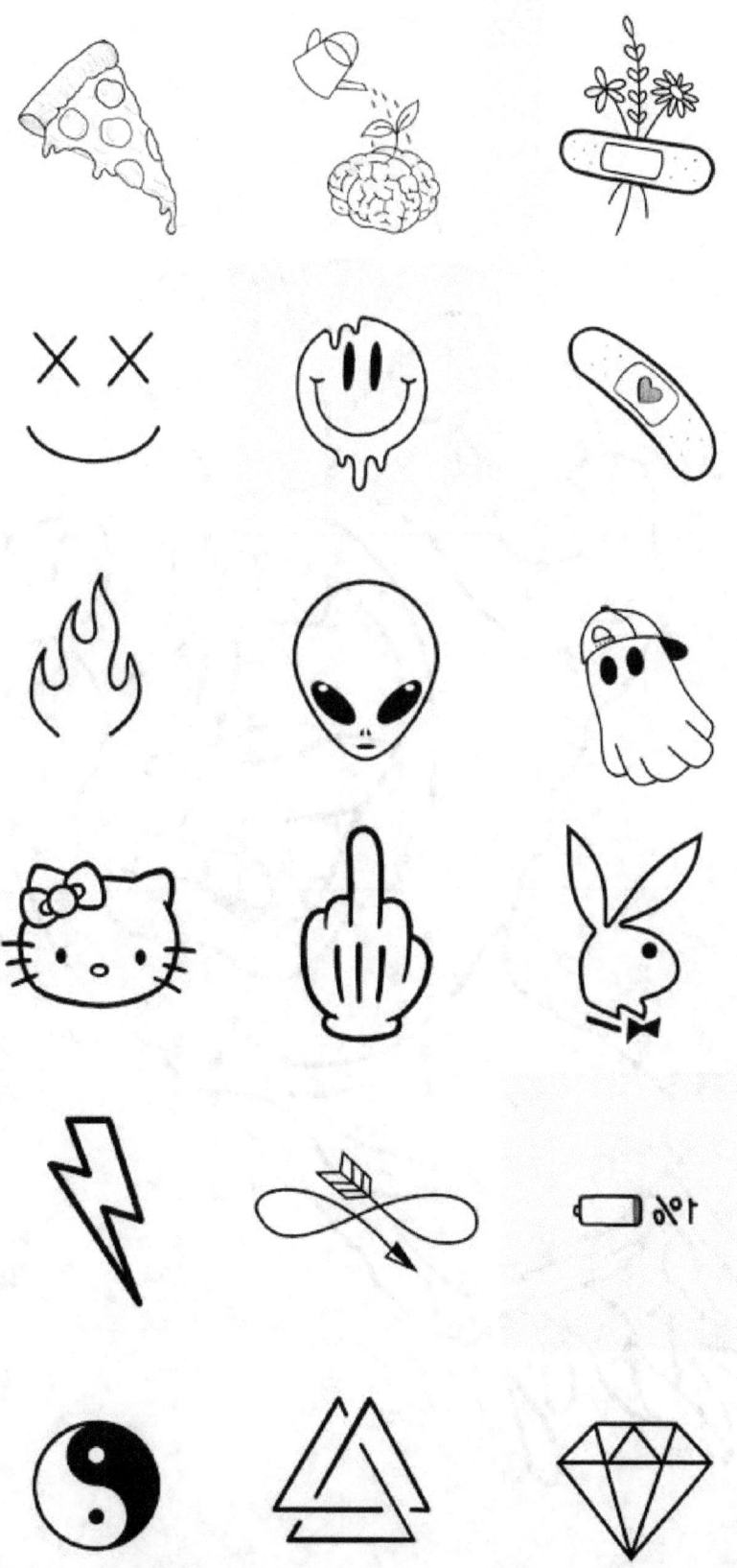

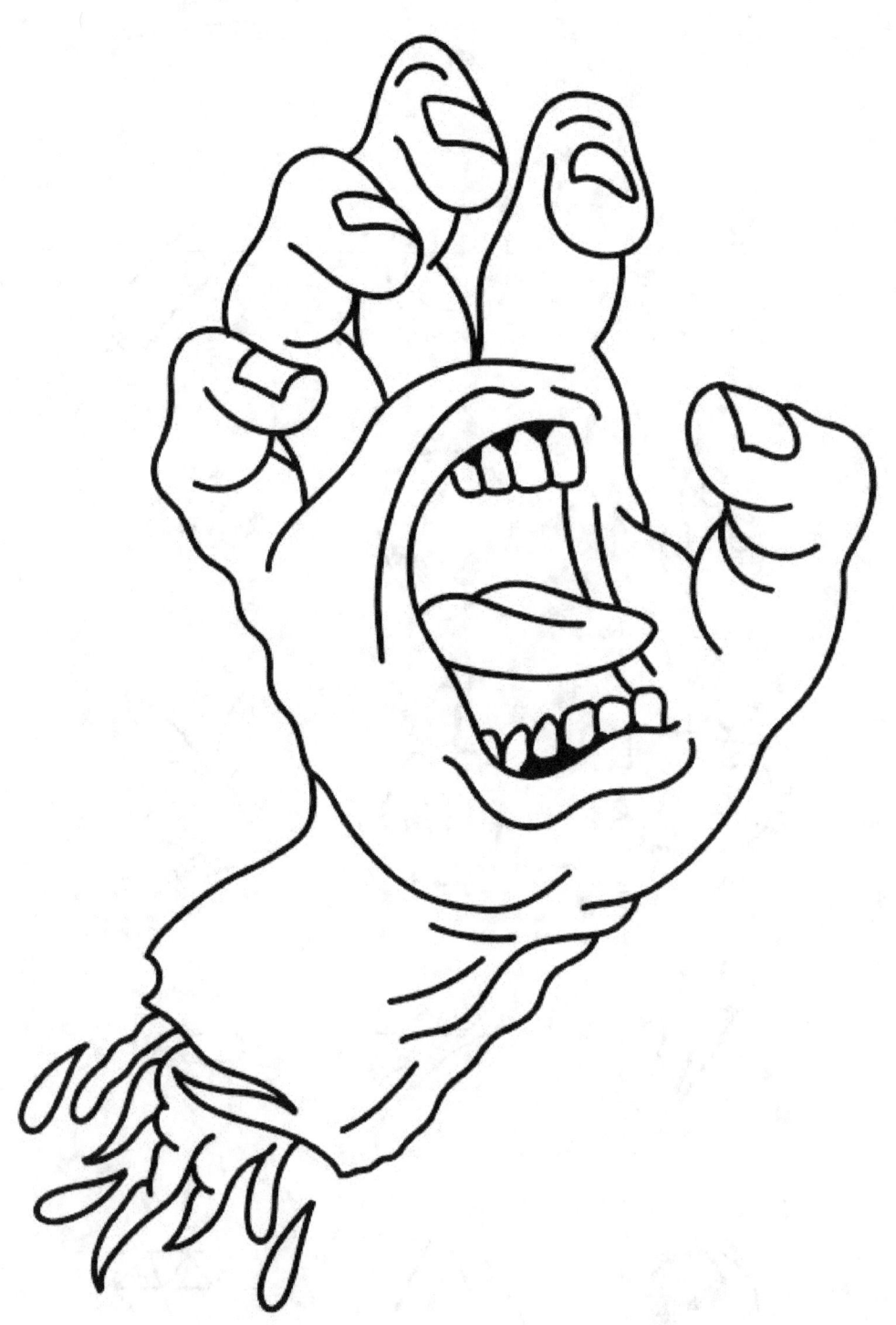

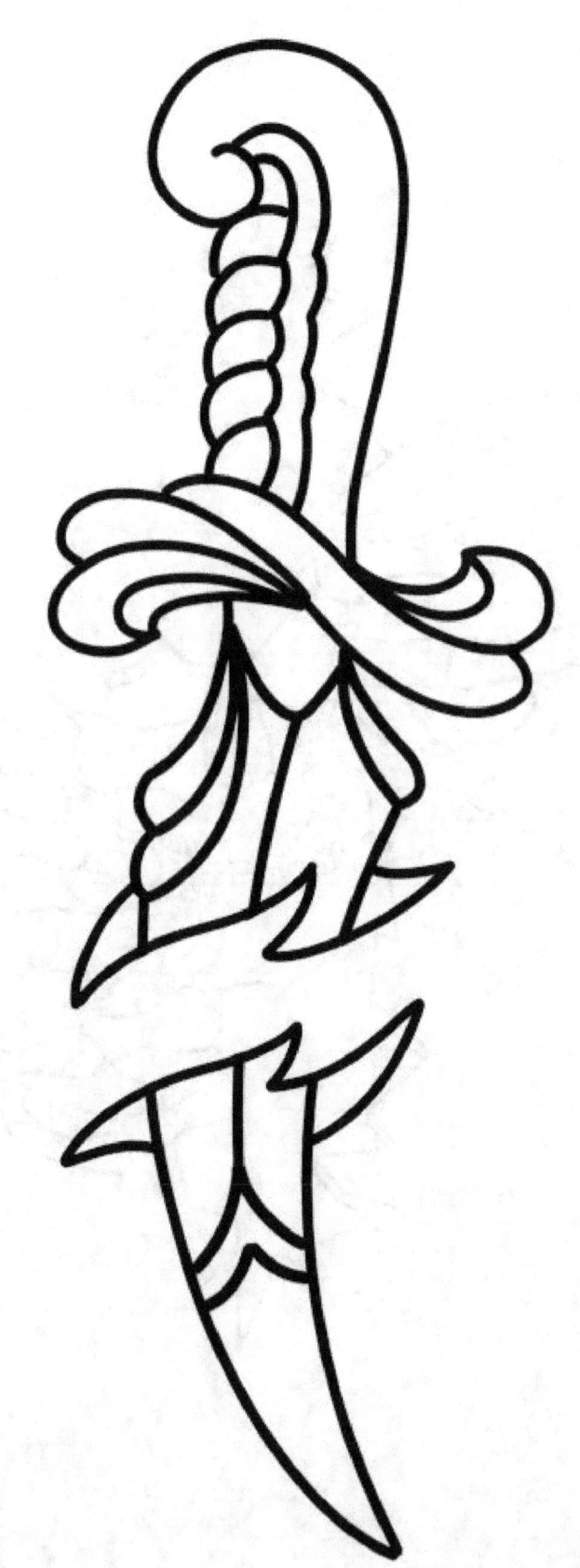

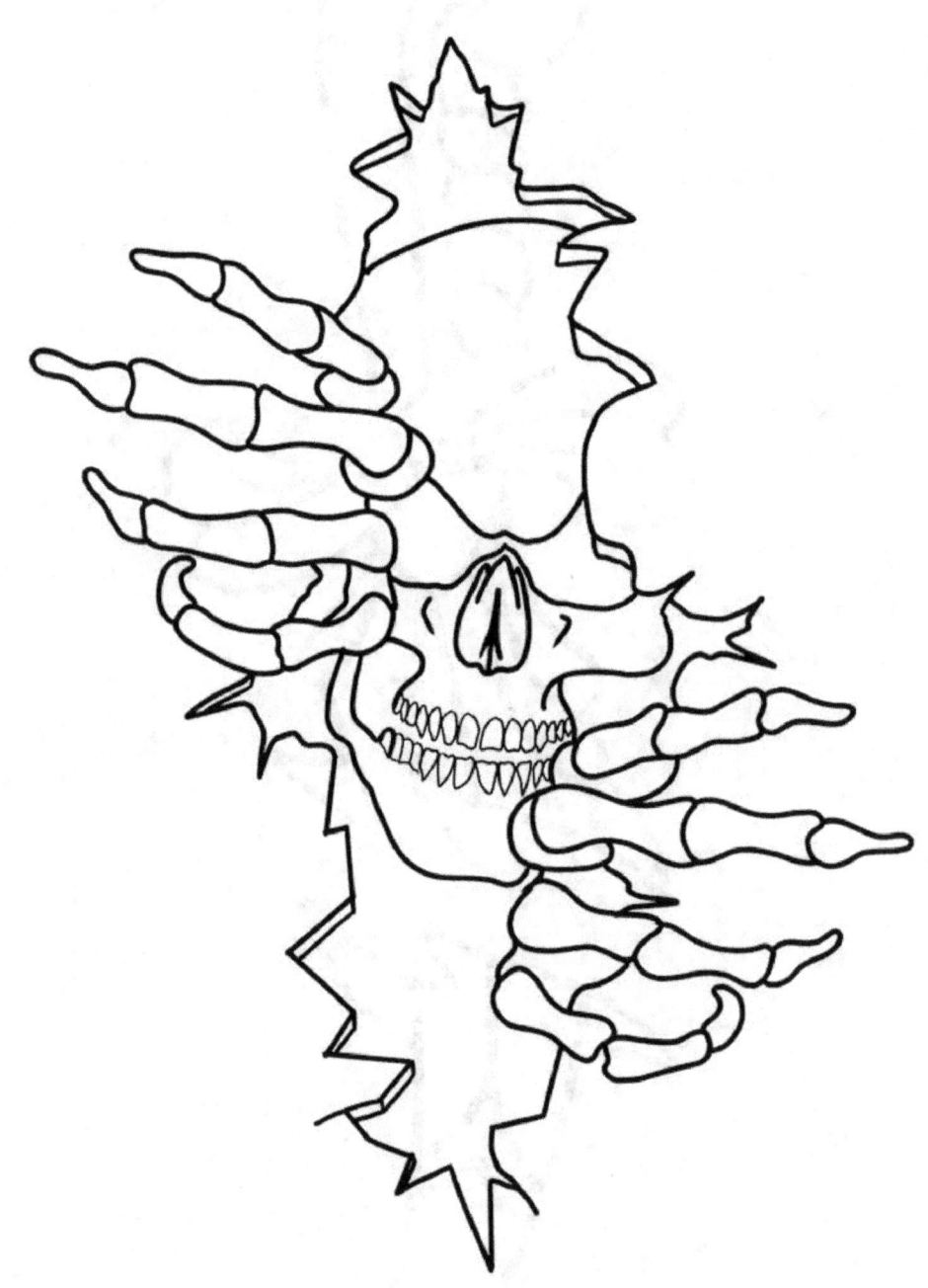

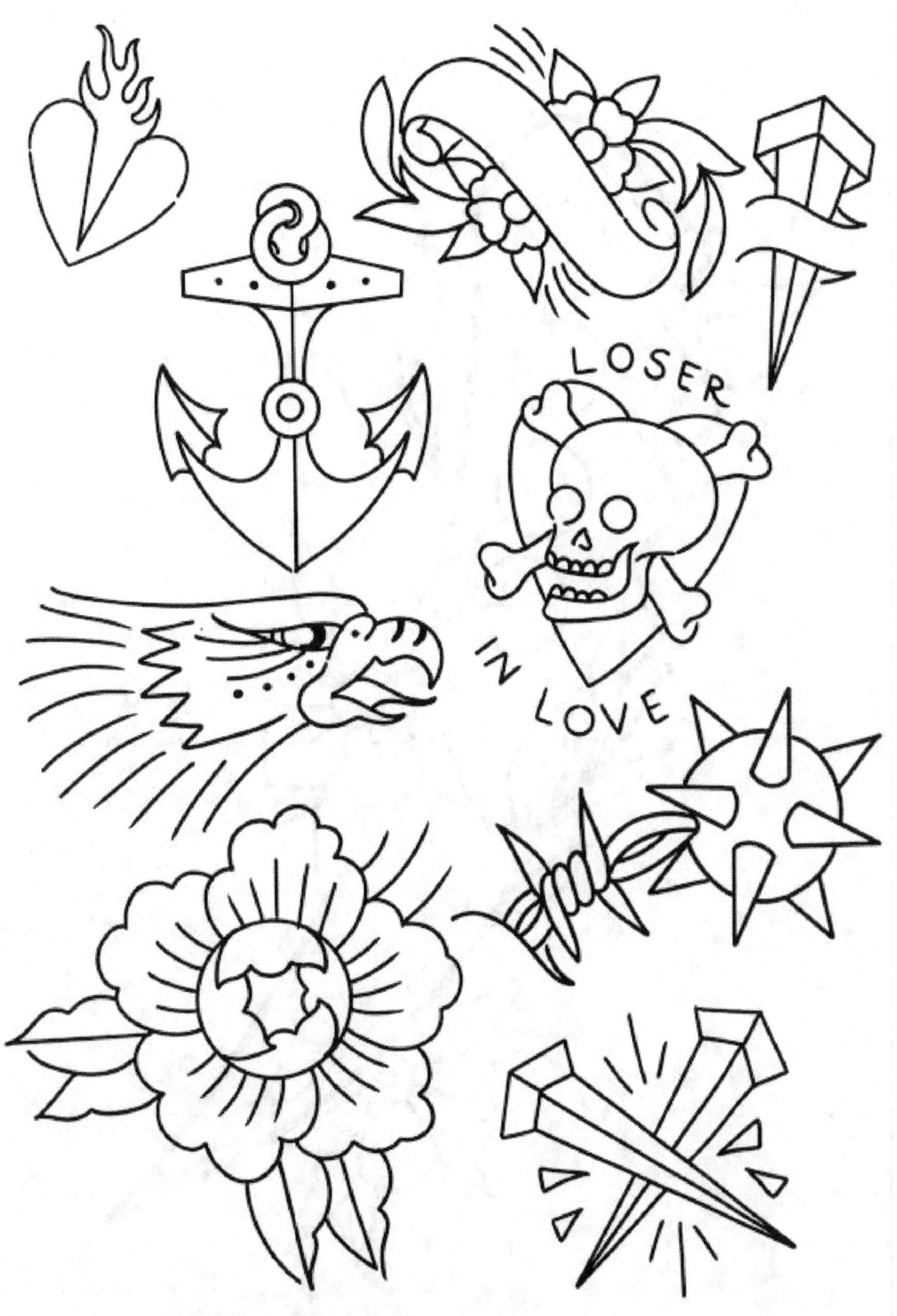

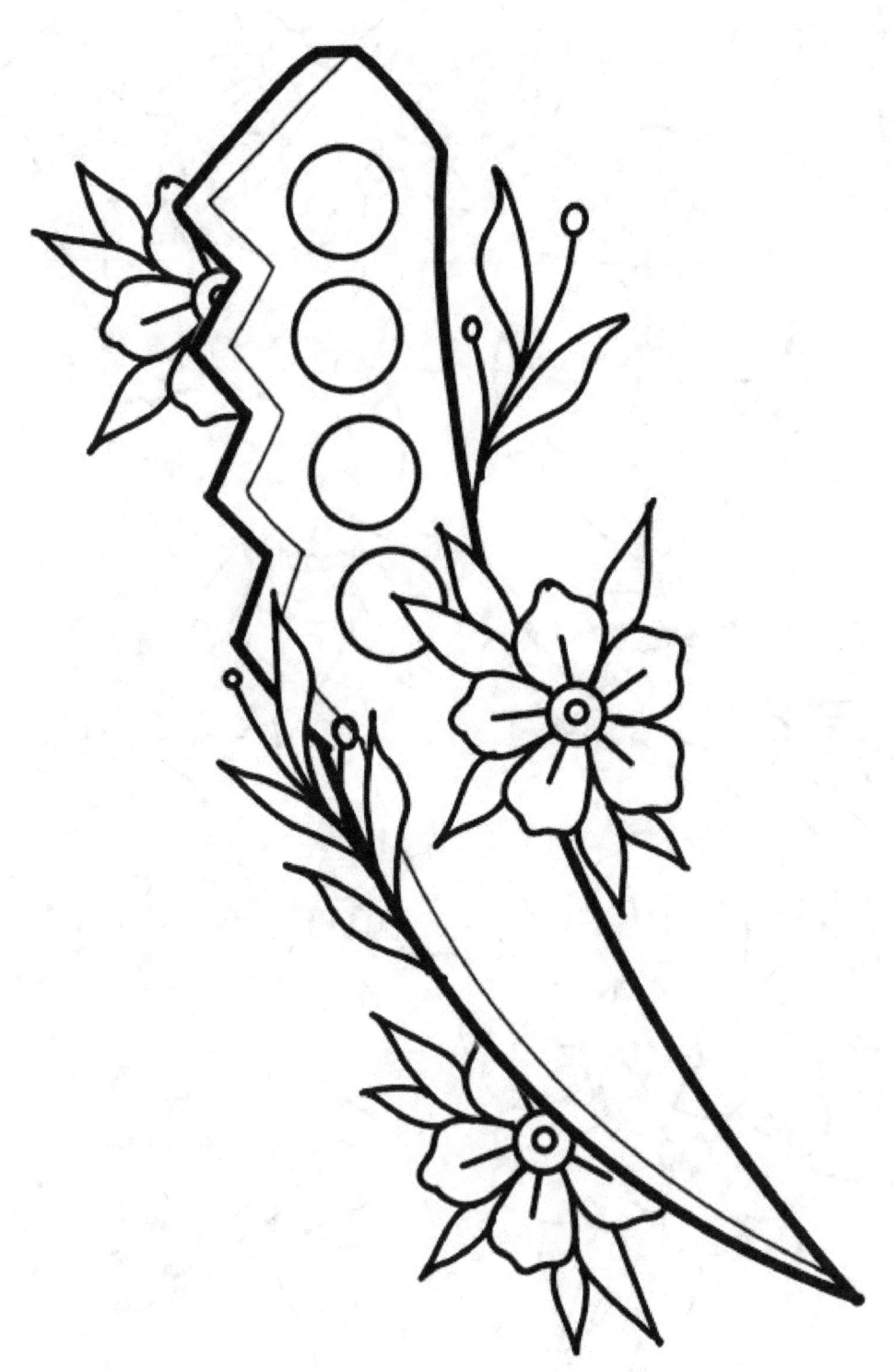

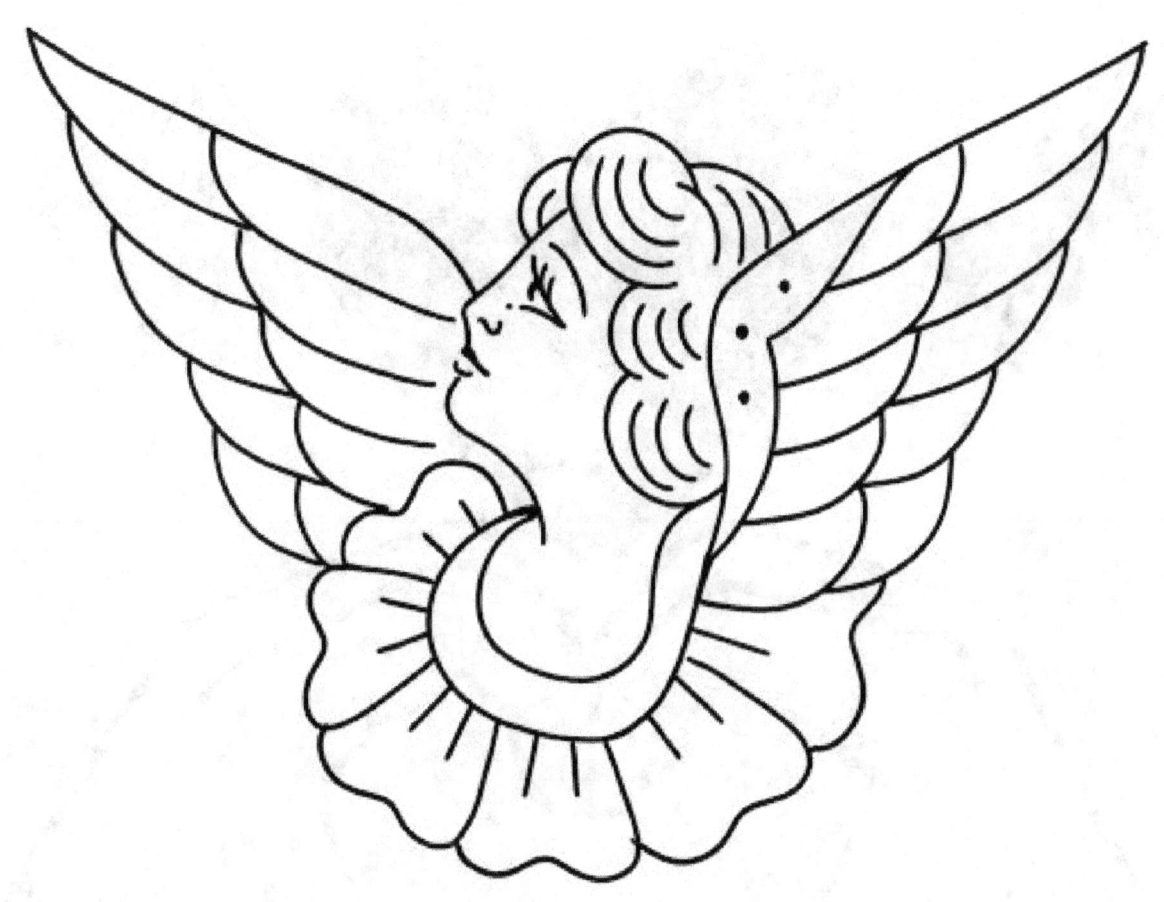

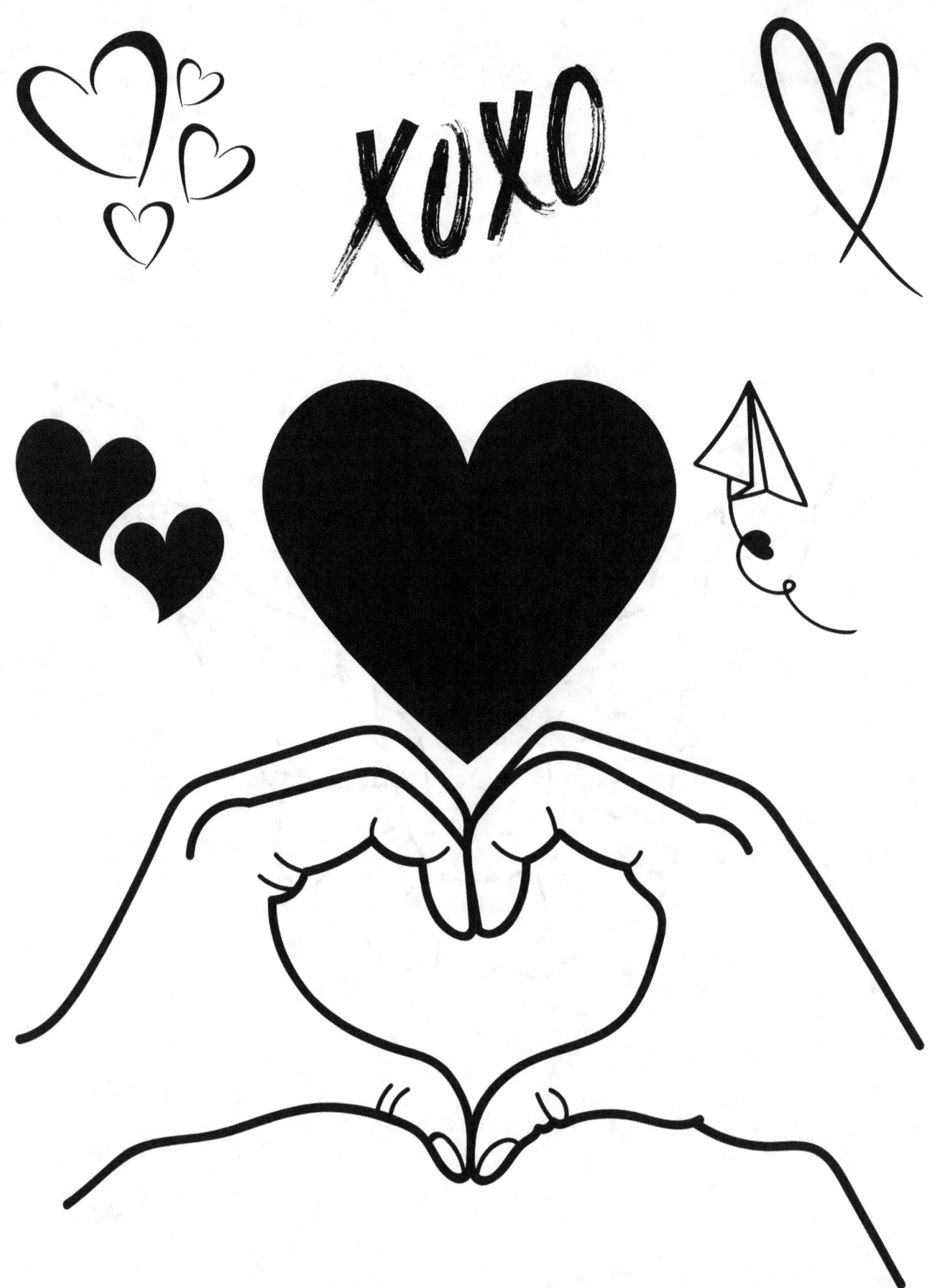

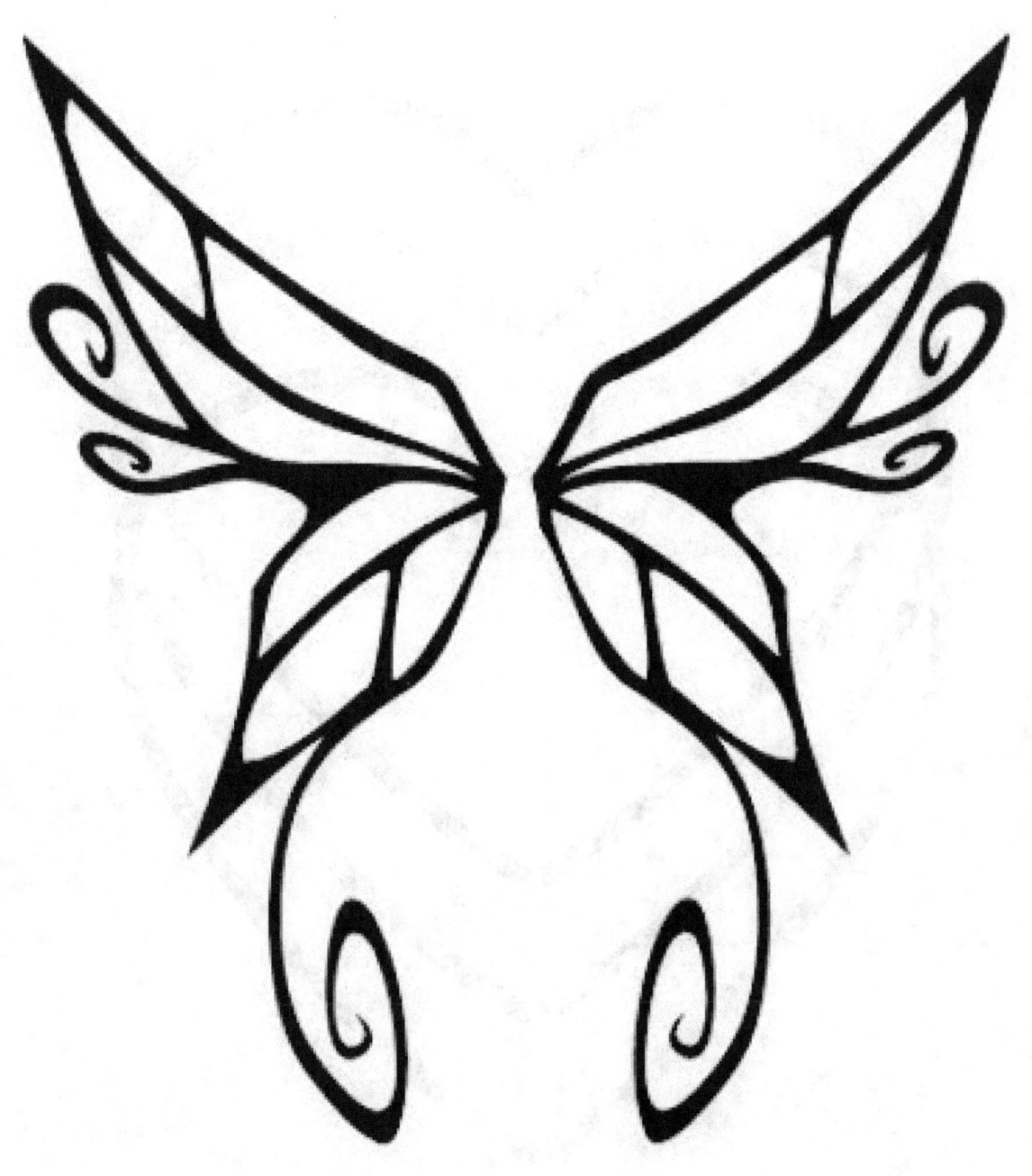

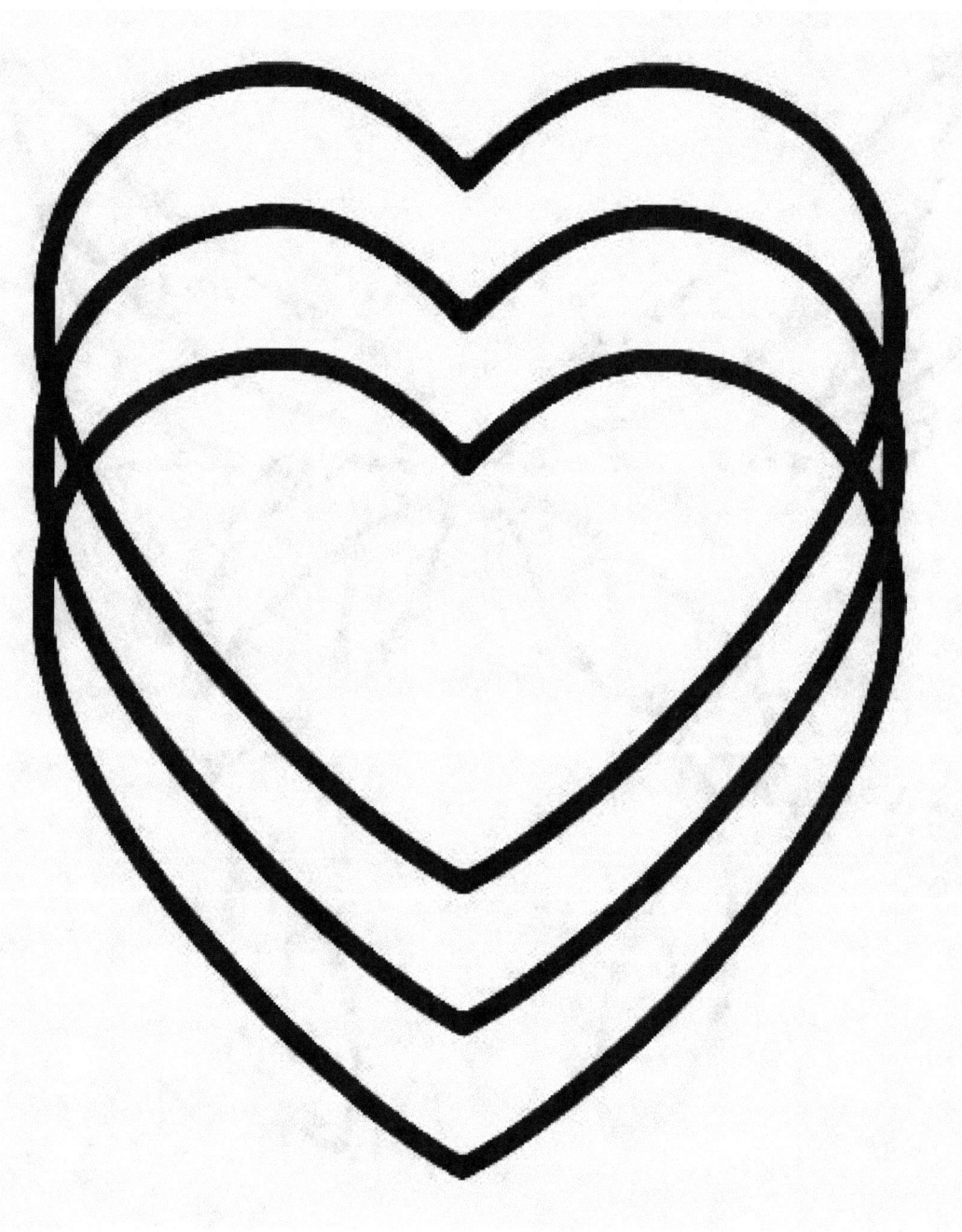

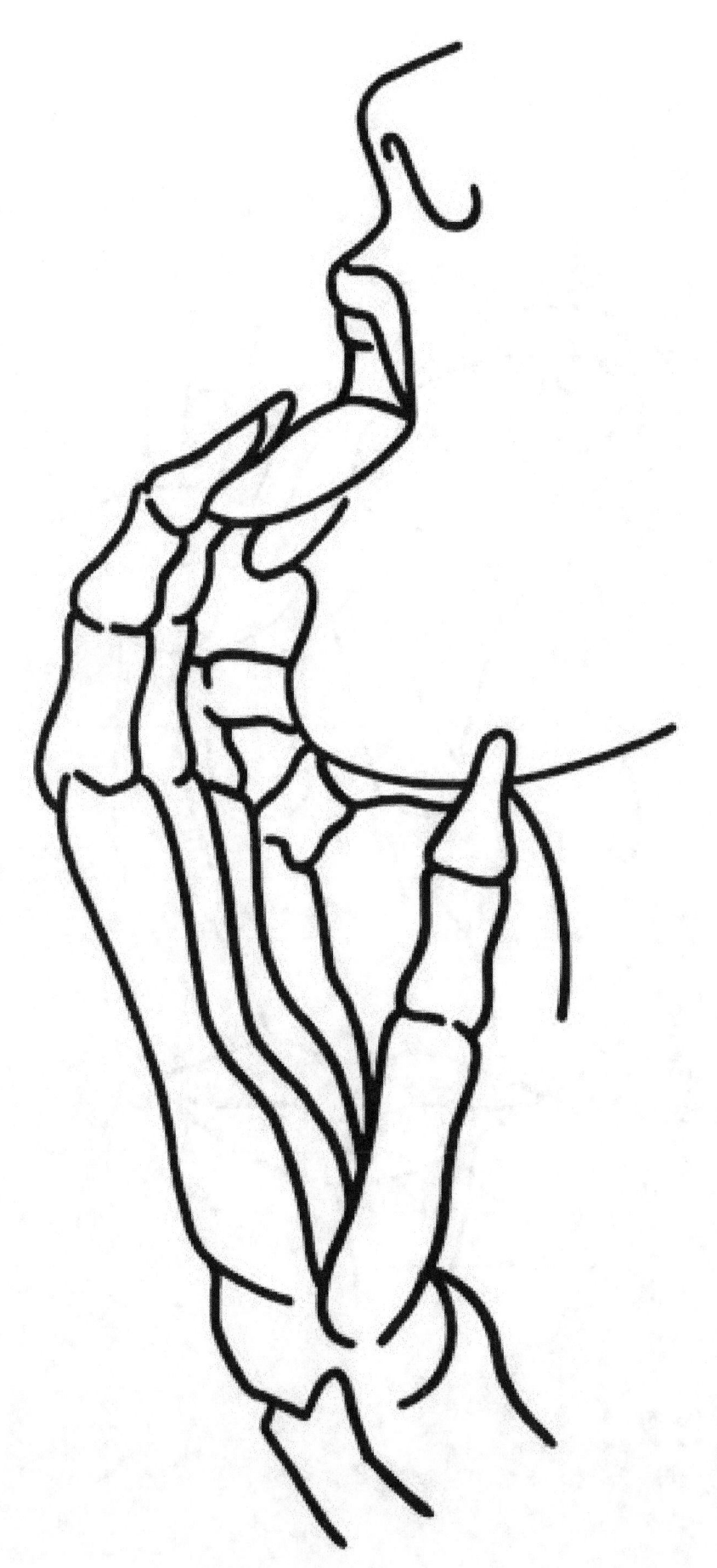

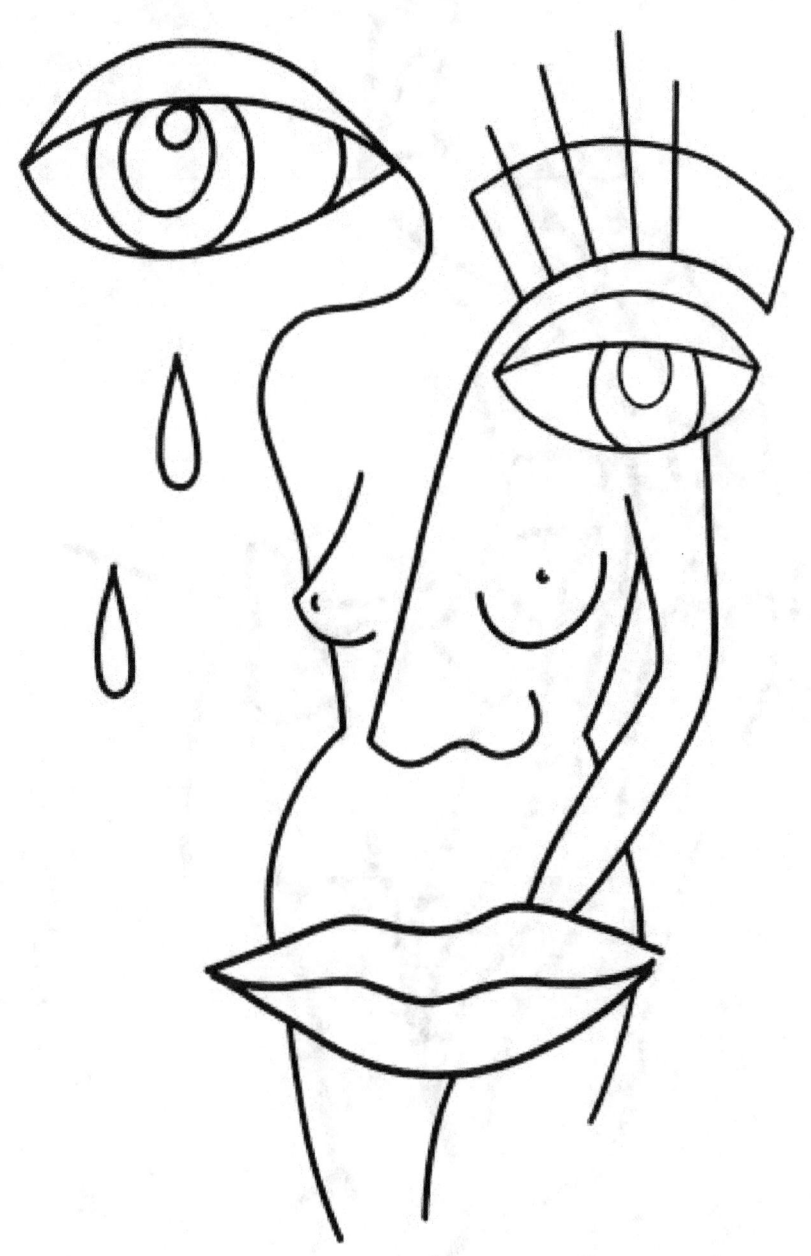

Thanks for your purchase

Thank you very much for purchasing one of my books! I am glad to know that you have enjoyed my work and I hope that you have found in it the inspiration and knowledge you were looking for.

If you are happy with your purchase, I would love for you to share your opinion through a review. Your comments are very valuable to me and help me to continually improve.

Get a free small design book in pdf format.
To thank you for your support, I would like to invite you to scan the QR code where you can access the free download. I hope you enjoy this little gift and continue to enjoy my posts.
Thank you very much again for your purchase and your time! I will be happy to receive your comments.
Sincerely,
Analía...

www.ingramcontent.com/pod-product-compliance
Lightning Source LLC
Chambersburg PA
CBHW082239220526
45479CB00005B/1283